NEW ORLEANS RUM

NEW ORLEANS RUM

A Decadent History

MIKKO MACCHIONE

Foreword by Chris Rose,
Pulitzer Prize winner and author of *One Dead in the Attic*

AMERICAN PALATE

Published by American Palate
A Division of The History Press
Charleston, SC
www.historypress.com

Front cover, top (from left to right:) All photographs by Stephen Charles Nicholson.
Front cover, bottom: Detroit Publishing Co., publisher. William Henry Jackson, photographer. *Cutting sugar cane in Louisiana.* Baton Rouge, Louisiana, United States, None. [Between 1880 and 1897.] Photograph https://www.loc.gov/item/2016817573/.
Back cover, top: The Charles L. Franck Studio Collection at The Historic New Orleans Collection, acc. no. 1979.325.160.
Back cover, bottom: Photograph by Stephen Charles Nicholson.

First published 2019

Manufactured in the United States

ISBN 9781467136846

Library of Congress Control Number: 2018963664

CONTENTS

BARREL OPENED

FOREWORD

Rum. It is historically the preferred libation of privateers and
buccaneers, Jamaicans, the Maritimes, Choctaw Indians, the
Royal Navy, Marco Polo, Hemingway, Hunter S. Thompson and
Jimmy Buffet fans.

Parrotheads notwithstanding, rum is one of the civilized world's most
popular, exalted, mysterious, mythological and misunderstood beverages. It
exists in species of light, dark and spiced. It has been the source of revelry,
rebuke, revenge and rebellions across the globe for eons.

Whatever name it goes by—Bacardi, Meyers, Captain Morgan, Nelson's
blood, kill-devil, demon water, pirate's drink, navy neaters or screech—rum
has been the source of grandeur, riches, ruin, camaraderie and betrayal
for centuries.

It is the drink of writers, kings and killers. It is the drink of literature,
romance and dreams. It is the drink of the islands, the open seas, uncharted
waters and unsettled lands.

The Little Drummer Boy; even he favored it. Rum-pum-pum-pum.

It is the drink of Louisiana, of New Orleans and of Hurricanes—four
shots of rum, fruit juice, grenadine, garnished with a slice of orange and
cocktail cherries.

Rum's history is both sweet and liquid. Distilled from sugar or molasses, its
origins are entirely unknown—or at least unproven. But rum is believed to
originate from archaic China and/or India. Its provenance is fluid, literally.
Everything about rum has changed, yet everything in time remains the same.

Made in China. Made in India. What isn't?

Made in New Orleans.

It is a conflicted drink.

There are towns named Rum in Austria, Iran and Hungary. The Rum River runs nearby the Twin Cities in Minnesota, from Mille Lacs Lake to the Mississippi River and thereby ending in, where else? New Orleans.

The Dakota Indian tribe's original name for that meandering Minnesota waterway was Watpa Wakan, which translates roughly as "River of Spirits." Legend goes that European interlopers to the Midwest mistook the "spirits" part for adult beverages and took to calling it the Rum River—a certain slight to those who looked upon their natural resources as gifts from higher sources than distillers.

There is a strong push among Native Americans and human rights organizations in the Midwest to return the river to its original name. But state legislators and general obstructors have been reticent to cooperate or concede, noting that the current name is so entrenched—and beloved—in the wider community, that any attempts to change it would be a fruitless and divisive enterprise.

Water, water, everywhere and not a drop to drink. But mix it with sugar or molasses and ferment it, and you have got yourself a commodity—one that folks are willing to trade for, fight for, honor or degrade themselves over.

Great Britain's Sugar Act of 1764—regulating sugar, molasses and the slave trade in the new colonies—is cited as among one of the chief provocations leading up the American Revolution. George Washington ordered and served up a barrel of Barbados rum at his inauguration in 1789.

Rum took on the moniker "Nelson's blood" because legend has it that, upon his victory, and subsequent death, at the Battle of Trafalgar, Horatio Nelson's body was preserved in a cask of rum for return to his native England. Having depleted themselves of other alcoholic options on the journey home to their Motherland, sailors aboard the HMS *Victory* tapped the deceased and pickled admiral's keg to salve their thirst.

The Rum Rebellion in 1808 came about when Captain William Bligh (yes, *that* Captain Bligh), serving as governor of New South Wales—the United Kingdom's convicts outpost later known as Australia—cut off the rum trade to and from the island.

Yo ho ho and a bottle of rum. Seaman's punch. The Easy Peace of port cities around the world. And the ingredient that makes the fruit burst into flames when the prim, proper and tuxedoed waiters at the legendary Brennan's restaurant in the French Quarter perform their ritualistic,

traditional, nightly, table-side immolated service of bananas Foster to the New Orleans gentry and genteel.

There is lots of sugar in south Louisiana, the homeland of pirates, hurricanes—both liquid and meteorological—and bars that never close. The state produces 17,000 tons of sugarcane a year.

That is a lot of sugar. That is a *lot* of rum. And not all the natives have historically appreciated sugar's distillation to spirits—the drink kind, not the ephemeral, ethereal and ancestral.

Choctaw Indian chieftains in south Louisiana originally objected to the widespread trade and dissemination of rum among their people due to the dissolute behavior it was known to cause among the tribe's menfolk.

An ancient document blames "all disorder and quarreling between us and our white men" to rum that "pours in upon our nation like a great sea." The Choctaws recruited the chief of the Red Stick Indians (that would be Baton Rouge in French) to their cause in the early nineteenth century, but individual acts of revolt and rebellion among the tribesmen quashed the chiefs' noble intentions.

Let the liquor flow.

And it has flowed downriver ever since in New Orleans. There are countless "daiquiri" bars across the region. It is a thriving cottage industry on the world-famous Bourbon Street—the Boulevard of Broken Dreams. But they are not really daiquiris. They are more like adult slurpees.

A daiquiri is—not just technically, but actually—a drink made from rum, lime juice and, according the authoritative mixologists' bible of the city—Stanley Clisby Arthur's 1937 classic *Famous New Orleans Drinks and How to Mix 'Em*—a dash of grenadine.

Arthur dismisses the local popular frozen daiquiri concoction as "a champagne glass filled with snow, cold as Christmas, and as hard as the heart of a traffic cop."

And it rarely contains rum. The contemporary version of psychedelic concoctions they call "daiquiris" in New Orleans, those favored by Saturday night rogues in the French Quarter, are generally infused with vodka, Everclear, Hypnotic and other strange and powerful brews that bear no relation to… purity, to rum, to sugar, to Jamaica. Hell, not even to Jimmy Buffet.

Rum needs a powerful spokesman here in the twenty-first century, the dawn of the craft cocktail movement. Who better than Mikko Macchione to lead us to the truth and the light?

This I can affirm and attest. For more than thirty years, we have shared triumphs, lies, women and hangovers because of rum, real rum, the nectar

of the gods, the source of hilarity, dance, brotherhood, some of the world's great literature…and not less than a few arrests.

But stuff happens. You bought this book. You are smart enough to know better than we did in our younger and more vulnerable years.

So *bonne lecture* from the Big Easy. One hell of a rummy town.

—Chris Rose

Chris Rose, New Orleans's beloved newspaperman and culture commenter, has spent a lifetime writing, first with the Washington Post, *then the* New Orleans Times-Picayune. *He is the author of* 1 Dead in Attic, *which became a* New York Times best seller. *In 2006, he won the Pulitzer Prize for his coverage of Hurricane Katrina.*

BARREL OF FRIENDS

ACKNOWLEDGEMENTS

Thanks to the following people:

Amanda Irle, for ridiculous patience
Laurie Krill, my wonderful editor
Stephen Nicholson, do you even remember taking these great photographs?
Andrew Farrier, for his selfless support and amazing knowledge
Elizabeth Nicholson and Andrea Pizza, for their wit, beauty and playfulness
Tatianna, for your faith in me
Historic New Orleans Collection, we (as in the whole New Orleans–loving
 world) are very fortunate to have these amazing folks
Alfred Lemmon, for savant knowledge of the city and for turning me on to
 "Entre Mi Mujer y El Negro" off the top of his head
New Orleans Public Library, because they take this history stuff seriously
Melissa Huguenot, for being generous and voodoo-licious
Dr. Elmer Glover, for being a positive light
Mike and Eugenia Rainey, for selfless friendship
Pirates Alley Café
Tony and Thais, for being fans and friends and serving great rum
Tujague's Restaurant, for having not only great bartenders, but for keeping
 New Orleans restaurants real
SoBou, for joyful cooperation
Atchafalaya Restaurant, for hospitality and enthusiasm
Old New Orleans Rum, for soaking me in rum knowledge

James Michalopoulos, for always saying nice things about my writing
Harry Mayronne, for being a musical and whimsical light
Karen Emerson, for bulldozing my life around so I have space to write
Jules "Dr. Jay" Malarcher, for being a genius goofball
Jaime and his staff at the Posada de Las Minas Hotel in Pozos, for letting me
 hang out all day writing in that beautiful space
Chris Rose, dude
The fifty or so Facebook friends that helped me name this book

SWEET RELEASE

Give strong drink unto him that is ready to perish,
And wine unto those that be of heavy hearts.
Let him drink, and forget his poverty,
And remember his misery no more.
—Proverbs 31:6–7

Way before the first Hurricane was mixed at Pat O'Briens in the French Quarter, before the first Mardi Gras parade stumbled its way down Canal Street, before New Orleans was founded, even way before King Lemuel's mother taught him to drink his biblical troubles away, humans have been distilling almost anything organic—from wheat to baby mice—into booze. Researchers have found traces of hooch as far back as 7000 BC China, where they fermented grapes, honey and rice into a thing, which sounds pretty good actually.

Evidence of alcoholic beverages have been found in every ancient culture—Egypt, Euphrates Valley, ancient Kazakhstan, pre-Columbian Mexico, sub-Saharan Africa and just about anywhere else people paused during brutal living conditions to party.

Spirits generally come from whatever grows locally: scotch from wheat, other whiskeys from corn, vodka from potatoes, gin from juniper and tequila from agave. That cactus becomes the most "normal" choice of mash as we examine different potations says a lot about what lengths humans will go for a nightcap.

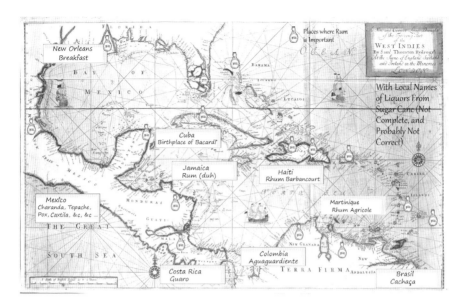

Caribbean map. *Lionel Pincus and Princess Firyal Map Division, The New York Public Library. "A chart of the West Indies, from the latest marine journals and surveys" New York Public Library Digital Collections. Accessed January 17, 2019. http://digitalcollections.nypl.org/items/510d47e1-cba1-a3d9-e040-e00a18064a99.*

In Indonesia, they make arak from coconut flowers; not to be confused with arak of the Middle East, where they use aniseed. Pulque in Mexico is conducted from century plants; Shochu in Japan from rice. In Ghana, akpeteshie is expressed out of palm oil. The Lao in Laos serve Lao. This is rice, but sometimes they add scorpions for flavor. In other remote places, different preparations are derived from esoteric plants and have flavors that may be judged along a scale of gasolines.

And in inscrutable China, where alcoholic potions have been used medicinally and recreationally longer than anywhere, they seemingly ferment anything that can be cultivated. Sorghum, barley, millet, rice, sticky rice, ginger, yak milk, something called Job's Tears and more end up in bottles. And yes, even newly born mice are fermented in some sort of moonshine to create a cure-all. Makes snake oil seem mild by comparison.

The point is, rum has a clear advantage, and it makes sense that it is so popular. Among the different stuff used to make alcohol—savory staples and exotic atrocities—rum stands alone because it is the only liquor made out of dessert.

For lucky cultures that could grow sugar, they had available a natural sweet potion that goes well by itself, in fruit juice, in milks, in cakes or body shots off friends. A dream that evokes escape, warm sand, zephyrs and time away from the boss—whether it be Club Med a half a planet removed from the cubicle or on the bounding main dodging the angry Navy. Rum just seems to be the flavor of sweet release.

Speaking of escape, "Sweet Release" could also be the name of a song about New Orleans. Rum just fits in here not only because of Carnival, 24-hour drinking, drive-through daiquiri stands, sugar growing easily here, but if for no other reason the water here is suspect.

It did not start that way. New England famously produced mega gallons of the stuff using imported sugar throughout Colonial times. Remember the infamous Triangle Trade—molasses to rum to slaves? Charleston would send sugar to Boston; Boston would send molasses to Barbados; Barbados would send rum to Africa; slavers would send slaves to Charleston. A theory why they started to make rum in New England is because they did not have any other groceries that tasted as good. With all due respect to the fine passionate citizens of the Northeast colonies, rum does not seem to fit their abstemious reputation—one thinks of sherry or a hard cider. But New Orleans! The populace and its personality fairly reek of rum.

Consider the Crescent City might have been the only place on earth where one could be in America, be warm, witness island folk, smell fresh-made molasses, see rum factories, drink in rum houses, admire pirates and marvel

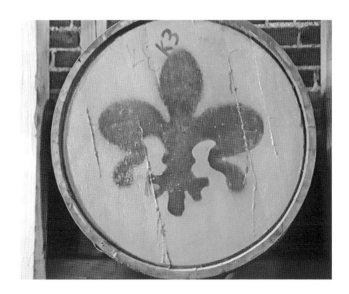

The fleur-de-lis provides crucial magic. *Photograph by Stephen Charles Nicholson.*

at a lenient government *and* drunk New Englanders in the same place. Heck, it's the same today.

Because both rum and New Orleans are symbols of far-flung, vaguely dangerous locales, where folks notoriously seem to loll all day, these two concepts get married in the national mind-set. Early advertisements brag about how New Orleans was an excellent place to find Barbados Rum— the implication being one did not have to go somewhere scary to enjoy esoteric delight.

Sugar is a relative latecomer to the area surrounding the port city, so the rum the early Creoles and other varied denizens drank was imported. And, like today, our little Paris in the Swamps has been a dispensary of any virtue or vice desired—or tolerated—by the locals. There is a charming note in *L'Abeille de la Nouvelle-Orléans* (The *Bee*, the French daily paper back in the day), where it asks the owner of the barrel of bear grease sitting on the dock by Barracks Street to please claim it, his barrel of rum already having been liberated by an unknown, concerned third party.

It is clear that the rum industry has never been centered in New Orleans, but it is also clear that there may be no better place on kind-of solid ground to celebrate that feel-good liquor that actually tastes good—rum.

BARREL ONE

WHAT IS RUM?

Elizabeth Swann: "So that's the secret, grand adventure of the infamous Jack Sparrow? You spent three days lying on a beach, drinking rum…"
[pause]
Jack Sparrow: "Welcome to the Caribbean!"
—Pirates of the Caribbean, *2003*

Speaking of rum, a fair question would be, what are we talking about? What is rum and has it always been what we love in our daiquiris and Cokes?

Distilled sugar products appear all over the tropics throughout history under differing names, some of which are still here. Rum and all its various cousins come from sugar. In fact, before we get to the panoply of sugar spirits, let's look at how New Orleans makes its rum.

In the part of the world New Orleans inhabits, sugar comes from cane. In other parts, they use pineapples, beets, honey, maple syrup, etc. The largest cash crop in Louisiana, sugarcane grows on over 400,000 acres of land, providing 13 million tons of cane a year. The industry employs over 17,000 people.

Sugar takes fourteen months to grow. The shoots are usually planted in mind-numbingly muggy August for an October-after-next harvest. The downside to this timeline is that the middle-aged stalks get exposed to an entire hurricane season. If the winds and rains lay flat the cane, it is virtually impossible to save the crop. Or as Robbie Robertson wrote in

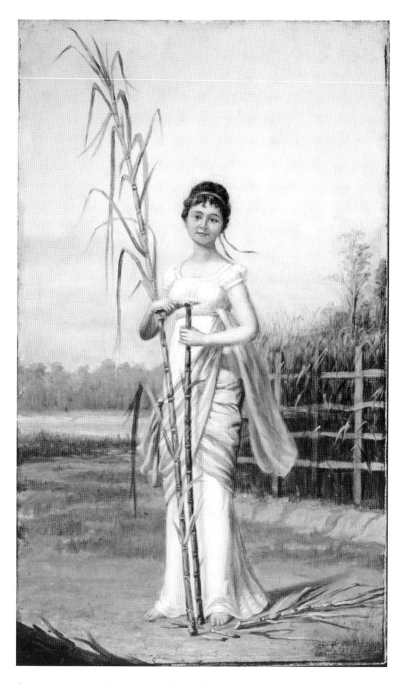

Queen sugarcane. *Courtesy of the Historic New Orleans Collection, acc. no. 1997.20.1.*

"The Night They Drove Ol' Dixie Down," "You can't raise a Caine up when he's in defeat."

It would have been a triple entendre had he written "when he's layin' in the field." Oh well.

The cane today gets chopped by large modern vehicles, but back in the day (and to this day in poorer areas, including the Dominican Republic), the crop was hacked down by machetes. Imagine doing this back in the 1800s. There are apocryphal stories that after the abolition of slavery, planters could not pay enough to get field hands to cut cane.

Before pressing, the stems need to be stripped of leaves, a tedious operation, so planters early on discovered the joys of pyromania. To this day, the skies of south central Louisiana are black with the smoke of sugar fields afire. And the newspapers are full of op-eds either supporting it as necessary farming practice or decrying it as a health and environmental threat. Burning the eight-to-ten-foot-tall stalks removes the leafy matter but does not harm the stalks. A nice side effect to this agricultural immolation is the heat forces the cane to push more juice to the surface of the stem, making the final product sweeter.

After the fire, only the cane remains, and it gets smooshed down in giant presses. In the pre-machinery age, mules did the grunt work as cane was fed into giant iron presses. The juice would be channeled into enormous copper cauldrons.

Some of these cauldrons survive to this day. Along the Louisiana countryside, these boiling kettles, too big to move, sit in front yards like ancient modern art. Folks have repurposed these pots into fountains and planters. A pleasant walk through the historic Garden District of New Orleans will discover original cauldrons sitting on the manicured lawns of the (probable) descendants of sugar barons.

The remaining fibrous cellulose, called bagasse, gets shipped off to be made into biofuel or the familiar house-building insulation called Celotex.

Now to the good stuff—cane juice's journey to the rum bottle. Once enough juice is collected, it is then boiled down into cane syrup. The first boil-through creates a thick, dark honey–colored product, which is locally called "cane syrup." This is the sweetest, and there are regional products, most notably Steen's Cane syrup, that end up on local children's biscuits and things. It is really good mixed with peanut butter.

Then it is boiled again, giving us molasses, darker and perfect for gingerbread cookies. A third boiling results in the evocative sounding "blackstrap" molasses, not so sweet but full of nutrients.

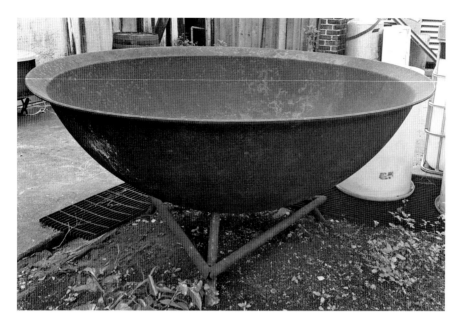

Sugar boiling kettle. *Photograph by Stephen Charles Nicholson.*

Rum is usually distilled from one of the first two pressings to get a good balance of sweetness and body. Adding yeast to the pressed juice—there are some processes that leave the barrels open to allow the natural yeast in the air to get to the juice—the product ferments, producing alcohol.

Because alcohol boils at a lower temperature than water, booze makers heat up the fermented juice, although not to boiling temperatures. This puts the fire in the firewater. The vapor is collected in long, helical tubes, where it turns back into a much higher proof liquid, the distillate.

The distillate runs through filters. There are three chemical parts to the distillate, sometimes called the "head, heart and tail." The tail has the lowest percentage of alcohol. It is acetone, the stuff you remove fingernail polish with. It is also used in making perfume. This contains fats, so a little bit can add flavor to the product; too much wrecks it.

The highest alcohol part of the distillate, the head, is ethanol—drink that and you go blind.

The heart, methanol, is the middle, the good stuff. This is what is "cut" from the distillate to be aged into rum. The liquid arrives clear, and to color it, distillers will age it in barrels. Some places use new oak barrels; some utilize used bourbon, scotch and even sherry barrels to effect different flavor notes.

Whew, science class is over. But here's the thing. Despite the technical details, there is a real subjectivity in creating good rum: Which pressing to use? How long to distill? How many times? Where to make the head/tail cuts? Which barrels to use? And a vat full of other considerations that make rum-making an art.

And when it comes to art—music, food, Mardi Gras, burlesque—New Orleans knows a thing or two. We even have nine streets named for the nine Muses. So the Crescent City emerges as a perfect venue for the creation of rum.

It is kind of funny, and fitting, that there is confusion around where the word *rum* actually comes from. It seems certain dictionary composers were *making up* origins of the word. One guy said it derived from the Malayan word *beram*, meaning "alcoholic drink." Another posited that it was a cousin of the Greek word *rheum*, meaning "flow, stream." Others like the idea of the word being a graft from *saccharum*, which is Latin for "sugar." Still another county heard claims rum came from India and points to the Sanskrit term *roma*, meaning "water."

Different flavor profiles. Like architecture and lovemaking, designing rum is part science/part inspiration. *Photograph by Stephen Charles Nicholson.*

21

Well, those are some theories. When whites arrived in Barbados, they discovered locals creating sugar-based spirits and called them "rumbullion" or "rumbunction," which are old British terms for a fracas. A bunch of islanders in a tropical paradise making rum—there's going to be some action! In 1651, a report out of Barbados said "They make in the Island Rumbullion, alias Kill-Devil, and this is made of sugar-canes distilled, a hot, hellish, and terrible liquor."

By the time New Orleans was founded a century later in 1718, the occasional British packet boat would drop off Barbados "rum booze" on our newly built docks.

The second question beyond where the word comes from is exactly *what* those early colonists were drinking. All throughout the New World exist rum-type beverages. Here is a (not complete) list of sugar liquors:

Aguardiente is made from sugarcane juice in many places; sometimes sweet fruits are used, yielding a rainbow of different products.

Brazil: *Cachaça* is not from molasses but from fermented sugarcane juice then distilled. This is the proper liquor to make the classic caipirinha. It is also known as *abre-coração* (heart-opener), *água-benta* (holy water), *bafo-de-tigre* (tiger breath) and *limpa-olho* (eye-wash).

Colombia: Aniseed is added to make a more "licorice-y" drink.

Costa Rica: Guaro is probably a contraction of aguardiente, a common sugarcane liquor name, made in Central America. Guaro Cacique is the top liquor in Costa Rica

Haiti: *Kleren* a strong clear sugar liquor; sometimes fruit is added.

Martinique, Haiti and other places in the Caribbean: *Rhum Agricole* is made from fresh sugarcane juice, fermented and distilled, and often aged.

Mexico: Mexicans love sweets. Almost every region of Mexico produces some kind of sweet potion from sugarcane. In mystical Michoacan, they produce something close to rum called *charanda*. In Guanajuato along the highway, travelers will see large orange barrels of *tepache*, a fermented brown sugar and pineapple juice treat. In remote Chiapas, they make *pox* (posh), a sweet sugarcane liquor. Up in the high desert of Sonora, bottles of Victoria with a simple bilingual label proclaiming it as *alcohol de caña* can be found. In Veracruz, the local indigenous people, the Nahua, drink *caxtila* at their *Xochitlaliz* (Flower Festival).

Tafia is what early New Orleanians experienced as rum. Tafia is made from molasses so it stands as the grandfather to modern rums. A case could be made that tafia was the cheap drink for locals, and rum referred to a more

nuanced, aged product for retail. In a lengthy 1851 *Harper's Monthly* article on Louisiana tafia, the word *rum* does not appear once.

Further, though there were no rum distilleries per se in the Golden Crescent, it seems a foregone conclusion that tafia would have been boiled up in the surrounding sugar fields. And clearly it was available. For example, there are references to city workers being paid in tafia for service, tafia appearing on receipts as a product AND as payment and tafia being available on the docks.

As we will see, it took awhile for the French to figure it out, but sugar grows really well here. To this day, the sugarcane fields go off in every direction around the city. And every now and then, as you may have heard, there is a party or two in New Orleans. So it makes sense that we are the northern tip of a geographic region starting in Brazil that could be reasonably called "The Great Rum Bucket."

LOUISIANA WAS FOUNDED ON A LIE

Si pa ni ronm, pa ni lapriè.
If you haven't got rum, you haven't got a prayer.
—*Creole proverb*

So, Louisiana was built on a lie. In the early eighteenth century, France was in big-time financial trouble. Louis XIV, for whom Louisiana is named, had just passed away, and his proactive economic policy died with him. As the new king-to-be was a child, the purse strings fell to a regent—Phillippe II, the Duc d'Orleans—probably better suited for apron strings.

Now it was not like Phillippe did not have options. Fifty years earlier, France established the West Indies Company (sometimes called the Mississippi Company, the Company of the West Indies or the French Company of the West). This company had solidified slave centers along the African coast and made a few lame attempts at making something out of its Caribbean holdings.

In 1682, Rene-Robert de La Salle came down the Mississippi River and stuck a large crucifix in the muck of the delta. The crucifix is very important because that meant that everything the Mississippi drained belonged to France. Despite the omnipotent cross, France had no idea how to exploit its bounty.

La Salle coming down the river to claim it proved to be a problem. After reporting his success back in Paris, he was given the word: "Good boy, now go back and build a port by which we can operate this magnificent waterway."

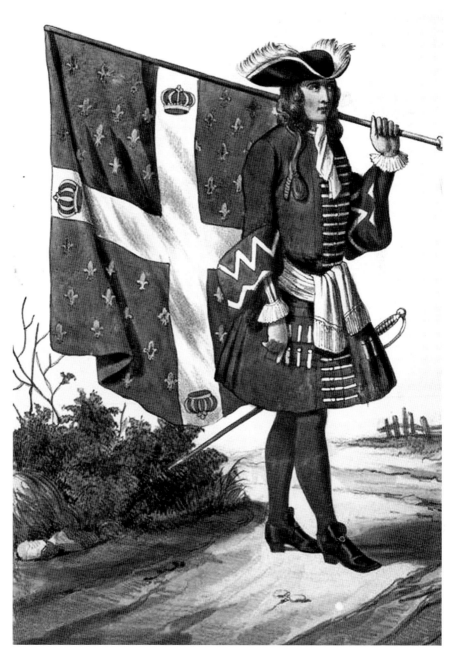

Frenchman with flag. *General Research Division, The New York Public Library.* "France, 1680–1700. *Louis XIV.*" *New York Public Library Digital Collections. New York Public Library Digital Collections. Accessed January 17, 2019. http://digitalcollections.nypl.org/items/510d47e4-3dd5-a3d9-e040-e00a18064a99.*

France never dreamed that sugar, the key ingredient in rum, could grow there; that comes along later. It had Louisiana, but what King Louis XIV really wanted was Virginia. Virginia was shipping boatloads of the best money crop in the world back to evil England: tobacco. Medicinal smoking and especially recreational snuff were so lucrative, Frenchmen were buying it illegally from the enemy. This drove the king crazy. So, off goes plucky Rene-Robert back to America.

Now imagine a desperate empty world, a harsh and unforgiving expanse of swampy coast. Imagine a world before GPS. The entire Gulf of Mexico coast from Florida to Mexico looks, well, the same. The Mississippi Delta forks and re-forks into shallow warm waters. Passes turn out to be cypress-clogged estuaries. The sugar sand beaches meant there was no Mississippi around. The mudflats and mangroves created a long green, secret curtain hiding the lusted river.

La Salle literally spent the rest of his life looking for ingress back to his precious giant crucifix. After extolling his men for years meandering along what is known today as the Redneck Riviera, the crew ended up way over in Texas. At some point, the crew, apparently sick of La Salle's optimism, took some initiative and put a bullet in his head.

Despite La Salle's fail, France was still desperate to have a Virginia. It had a big river and trees, and it wanted to make some money off it. Well

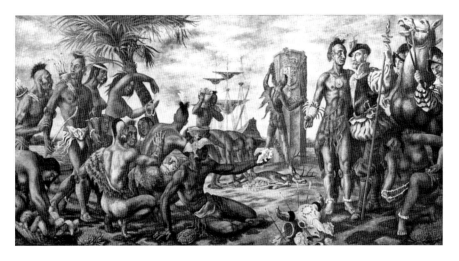

French and Indians. *Photograph by Carol M. Highsmith. Mural "French explorers and indians" by Karl R. Free at the Ariel Rios Federal Building in Washington, D.C., United States, September 2011. Photograph. https://www.loc.gov/item/2013634490/.*

thank Hades, the god of wealth, for John Law because he turned out to be a freakin' expert on exploitation.

Law was a Scotsman who somehow got the ear of the French government and created what was basically a central bank. This bank dealt in a weird new idea called paper money. The idea was that the bank would leverage its business against the national debt. Law then got weirder and took the Mississippi Company, rebranded it Company of the West (I know, I know…) and looked to find people crazy enough to actually go work there.

So, they made stuff up. All throughout the financially strapped nation, the company put up posters proclaiming things like: "Come to Louisiana! Mine the mountains of gold, silver and lead!" For those who are geographically challenged, the highest point of Louisiana is half as tall as the Eiffel Tower. "The Mulberry Trees are Crawling with Silkworms!" Well, not so much. We have red mulberries, but silkworms like *white* mulberries. "Black Peppercorns Fall From the Trees!"…You get the idea.

The opportunists, shady characters and scoundrels that responded were not exactly the brightest crayons in the box. The unforgiving mud, humidity, mosquitoes and rain bore down on these new colonists, and somehow, they dealt with it. But then a more pressing need emerged: "Dear King," they wrote. "Please send us some women."

So, the king sent nuns. The Ursuline Sisters were the first white women to arrive, and though they were not the wives the ardent colonists desired, they provided needed services—education, spiritual and medical. Up until very recently, religious sisters were allowed free access to public transportation.

The Ursuline Sisters also provided another service: they defended the city from calamity. When the first nuns came over, they brought a small statue of Mary the Blessed Virgin, or as the Catholics referred to it, "Our Lady of Prompt Succor." Ahem. It means "fast help." In 1812, a massive fire swept through the city. The Ursuline Sisters set the small statue up to face the oncoming flames, and they died out across the street from the convent.

A few years later, the intrepid Ursuline Sisters faced the so-called Sweetheart Statue toward Chalmette, where a handful of Americans faced off against an overwhelming number of British soldiers. The Yanks pulled off a miraculous victory, and "Our Lady" once again granted our city "Prompt Succor." Every year, when a hurricane is looming off the coast, there is a vigil to the statue.

The colonists tried again. "Dear King," they panted. "The nuns are great, they are so cute, thank you. Now, could you sort of send us some real women?"

Now the king was thinking, "We're still in debt, why don't we send women who are a drain on the economy?" So, they emptied the prisons and the public houses, and they forced marriages: "For stealing that croissant you get fifteen years, or marry this trollop and go live in the New World." We were not getting debutantes here.

The first women arrived clutching little wooden boxes known as *cassettes* (little cases). The boxes held linens, girly things and miscellanea the young ladies needed. These so-called cassette girls stayed with the Sisters at their majestic convent in the heart of today's French Quarter. And, as they started integrating into the city, they became the first legitimate wives in the French New World.

Over time, these boxes—combined with some folks' yearning desire to tell "a better story"—have been morbidly renamed *caskets*, which proves to them that these first ladies were vampires. Today, certain "tour guides," dressed like chimney sweeps with glowering faces, stand in front of the Old Ursuline Convent and reveal dark tales of how these little "vampirellas" came to the New World bearing their own coffins. They further go on to reveal that the Catholic Church preserves the undead bodies of these bloodsuckers in the heavily locked and blessed attic of the convent.

Back in the real world, while France engaged in creating a love connection for the colonists, here in the colony a couple of French Canadian brothers—Iberville and Bienville—were poking around looking for some high(ish) ground. They had cleverly found their way *down* the river and discovered an Indian outpost on the Mississippi that was a dizzying six whole feet (two meters) above sea level. They also discovered that there was this nifty lake about five miles away, and there was a bayou that ran from the lake to within a few hundred yards of the river.

A bayou is a slow-moving distributary of water that lolls away from a larger body. They wind through the swamps of Louisiana and Texas and are typically filled with alligators and Spanish moss. Bayou St. John is a controlled, well-groomed waterway today, but in those early days, it was swampy and dark and *the* way to easily get from the Gulf almost to the river.

The cool thing about Lake Pontchartrain is it has an easy-to-find entrance from the Gulf of Mexico. Sea captains would come from the Gulf, through the passes, to Lake Pontchartrain, hug the south shore till they came to Bayou St. Jean, take a left and end up a thousand paces from the river. Then it was a matter of carrying cargo over the above–sea level land to the Mississippi.

By 1718, Iberville had sadly passed, but Bienville remained. He plunked down soldiers, some sheds, a church—and no doubt a drive-through daiquiri

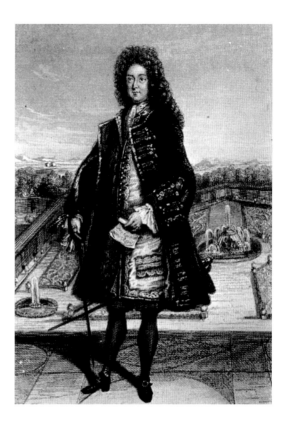

John Law, eighteenth-century Scotsman, credited by some historians as being "the father of inflation." Law turned gambling IOUs into "gold counters," then state debts into paper money and finally sold all France down the river on the "Mississippi Bubble." *United States Office Of War Information. Inflation. United States, None. [Between 1940 and 1946] Photograph. https://www.loc.gov/item/2017696879/.*

stand—and honored the Regent Phillipe with a new name for the port: Nouvelle Orléans.

History does not report whether they found La Salle's cross, but they did get an expert to design a town—today's French Quarter—which has pretty much the same layout. The streets were named after the guys who were paying for the trip.

The street the church is on is called Chartres. Don't overthink it, even French speakers have trouble saying it. Here, we say Charters. The town of Chartres, in France, is the hometown of the king's family. Royal Street was named for the royals. Bourbon Street has nothing to do with the whiskey but is the actual family name of the king. As of yet, there are no streets named for rum.

Going the other way, the first two streets are named Iberville and Bienville; fair enough, they were doing all the work. The next ones are named for the assorted children of the king—or rather their patron saints—hence St. Louis, St. Peter, St. Ann and St. Philip. But the king had more kids than that, wink wink. Couldn't put saints names on those streets, could they? So

they put their titles up—Conti, Toulouse, Orleans and Dumaine. So, in the French Quarter it is easy to remember the street names. They go bastard/saint/bastard/saint/bastard/saint.

With a new port and suckers going over to work there, John Law gets another weird idea. He starts selling stock in the Whateveryoucallit Company.

What happens next is real financial and confusing, so see *The Big Short*, *Wolf of Wall Street* (either version) or even *It's a Wonderful Life* to get an idea of what happens in a financial panic. At one point, one share was selling for 15,000 livres, and less than a year later, they were worth 4,000. Soon the paper was good for wrapping fish.

The end of Law's meddling resulted in inflation being invented, the word *millionaire* getting coined, France plunging into terrible poverty and a new New Orleans teetering alone in hurricane country.

And here is why the Buddha smiles: Tobacco does not grow well here.

FROM THE GOD SQUAD
TO THE FIRING SQUAD

Tafia toujou die veité
Rum always speaks the truth
—Creole proverb

Right off Canal Street, where the Roosevelt Hotel sits today, was the edge of an enormous sugar plantation. It was the purview of some brave clergymen who had come to the New World on a mission. These plucky priests supported themselves with the proceeds of sugar syrup and that wonderful proto-rum, tafia. This would have been 1751.

About two hundred years earlier, St. Ignatius Loyola started the Society of Jesus, or the Jesuits, inspiring them to be self-denying, tough, prayerful and absolutely dedicated to the Papacy. They were commanded to be "as obedient as a corpse."

Okay, a little intense, but it was just this sort of zealotry that intrigued politically conscious popes to utilize these guys. The Jesuits took the dead body feeling out of their brand by choosing the motto *Ad Maiorem Dei Gloriam*," meaning "to the greater glory of God," implying a sort of "Oorah!" for the Vatican. You can still see the letters AMDG carved into the cornerstones of Jesuit buildings today.

The first Jesuit to arrive in New Orleans was Father Francois Xavier de Charlevoix, who came when the village was three years old. He immediately saw dollar signs and reported: "I have the best grounded hopes for saying that

this wild and deserted place, at present almost entirely covered with canes and trees, shall one day, and perhaps that day is not very far off, become the capital of a large and rich colony."

The main obstacles to wealth from the New World were concerns about acclimatization, what crops to grow, getting God's help and most importantly, coexisting with the indigenous peoples. The papal swat team was perfect for the gig:

> *First and foremost, missionaries must be stationed in the midst of Savages which separate us from the English and as these are constantly endeavoring to win over the Indians and excite them to rise against us, it is absolutely necessary that the missionaries to be sent there be clever, active, and alert. Among all the Religious Orders in the world, the Jesuits alone are such. Therefore, we need them.*

These are the actual words of the Colonial Council nervously begging the king to send some Jesuits to come in and protect them; seemingly implying that other orders of priests were not clever, active or alert. Father Beaubois came in and purchased a nice chunk of land; today, it is the entire Central Business District from Canal Street all the way up to the Lower Garden District. The plantation allowed the Jesuits to create their own income— handy for not having to put up with any sort of outside interference. And as the Jesuits had great success with sugarcane in what is now the Dominican Republic and other places around the globe, they become the first folks to grow it here.

The priests were turning out large volumes of sugar, molasses and hooch. Some histories downplay it, noting they were only producing enough for themselves; while other accounts describe how their rum was the only game in town. In the beginning, everyone could kick back with a rejuvenating cup of tafia, feeling content, secure and religiously correct. But it only took a decade for attitudes to sober up.

By the 1760s, fears of Indian uprising had subsided to be replaced with a new concern: How did the Jesuits get so rich? And can we have a piece? The new zeitgeist across Europe was obsessed with separating church and state. Also, in a growing time of nationalism, it was hard to sell subservience to the pope in Rome as a good thing.

Throughout the world of different empires, a monumental backlash beset the Society of Jesus. All over Europe, New France (Canada), New Spain (Mexico) and many more places, some as far away as the Philippines, Jesuits

were bitterly repudiated. Their lucrative plantations and other business operations were confiscated, and the priests themselves were expulsed from many territories. That fever hit New Orleans.

Attorney General Nicholas Chauvin de Lafreniere convened a Superior Council, with lay shopkeepers and merchants. These non-priest entrepreneurs then got a copy of the Jesuits' own constitution. They found it allowed religious men to make money on top of the donations they already received and the special considerations they historically got from the crown. It took the jurists just over a week to basically say: "This is outrageous! Get out!" They were either entirely justified or entirely anti-Vatican, depending on which history one looks at. Either way, there was quite a bit of wealth the hardworking holy men had accumulated, and guess who was getting cut out?

The 1763 Decree of Suppression of the Society of Jesus in Louisiana lowered the boom on the order. The (very valuable) land was expropriated. It is not clear what the value was at the time, but today, it is home to city hall, the Superdome, the entire Central Business District and fourteen of the fifteen biggest hotels in the city. The council conducted an eight-day auction, including barrels and barrels of tafia, with the proceeds no doubt going into public coffers. The priests, who can be seen as both heroes and villains, were all sent sailing back to France.

By 1773, Pope Clement XIV had declared a worldwide suppression of the Jesuits. It was not forever. The order has clearly made a comeback in the modern era. Interestingly, New Orleans today is home to a great Jesuit university, Loyola, and one of the top schools, Jesuit High, has been the alma mater of many mayors (Moon and Mitch Landrieu and Marc Morial), national entertainers (Dr. John and Harry Connick Jr.), pro athletes (Rusty Staub and Will Clark), my son and other all-around great men.

The loss of the Jesuits seems to have been viewed as a win/win by folks at the time but something else important was lost: locals forgot about sugarcane for a while. The only way to get any good stuff now was off naughty British packet boats—the Amazon Prime of the time. These boats made scheduled stops with mail, news, small items and rum, of course. The boats never really docked; they would come up the river a few hundred feet from shore because legally they were not allowed at the French port. However, the crew would gladly sell Barbados rum to anyone with a rowboat.

Having been instrumental in removing the Jesuits, Lafreniere's xenophobia and big mouth would finally land him into real trouble.

British packet boat. *The Miriam and Ira D. Wallach Division of Art, Prints and Photographs: Print Collection, The New York Public Library. "To the British and American Steam Navigation Compy. this print of their splended steam ship the British Queen." New York Public Library Digital Collections. Accessed January 17, 2019. http://digitalcollections.nypl.org/items/510d47d9-7a9c-a3d9-e040-e00a18064a99.*

In 1768, a little Spanish governor bounded off his little boat with a couple of flags and a few cannons and announced that we were all now subjects of Spain. And the French were like, "Le OMG!"

At the time, France was doing what it always does—fighting England—and doing what it always does—losing. France lost Canada; it most certainly did not want to lose Louisiana. So the French king kinda sorta gave it to his cousin King Carlos III, of Spain. Only he kinda sorta did not tell anyone.

The French business folks, who were doing just fine merci beaucoup with some side shady dealings as well, did not want any annoying Spaniard in the works. In true New Orleans style, a plot was hatched.

Lafreniere and five other rabble-rousers—plantation owner Joseph Villere, Bienville's nephew Jean Baptiste Noyan, Pierre Caresse, militia commander Pierre Marquis and Joseph Milhet—became a cabal that attempted to move the people against the new developments. Some of them went to surrounding areas to decry this Spanish outrage. Marquis organized parades through the center of the city. Downtown businesses prepared not to cooperate with the new jefes. Riots broke out.

The people wrote letters to different French muck-a-mucks in France imploring them to keep New Orleans French. They all replied, "What's done is done. We can't go back." There were now more protests. It is not clear if there was any actual military action. In response, the Spanish governor Antonio de Ulloa imposed a curfew and basically placed an embargo on the city, hoping to erode support for the rebels.

In a dispatch from one of the French king's observers, the reporter commented:

> *They are after all but pretty bad fellows, who, loaded with debt, seem striving with eager emulation to avail themselves of the overthrow of the colony, in order to retain, with impunity the funds advanced to them. I think were it not for them, I should no longer stand witness to the most indecent and outrageous deportment. There would no longer be any reason to fear the execution of the detestable project of burning New Orleans.*

He did not mean a literally burning New Orleans, he meant everybody was crazy angry. Finally, Ulloa and his pregnant wife were escorted onto a ship, and it set sail for anywhere but here.

And everything was great…for about a year.

A whole fleet of ships came up the river, this time with a lot more flags and a lot more cannons, and a different governor stepped off a boat. This guy was a Spanish war hero, handpicked like Winston "The Wolf" Wolfe from *Pulp Fiction*, to go chill the French out. His name Mariscal Alejandro (wait for it) O'Reilly. Yep, an Irish guy.

Spain colonized with diversity. And if you were going to pick any guy to crack the whip, O'Reilly would have been the one. He fought in France, then fought for the Austrians and then went to administrate chaotic Havana to clean military house there. Now, with the fate of the most important continental possession in the balance, he got the word: Go to New Orleans.

O'Reilly came in, invited the alleged rebel leaders to dinner and promised a thorough investigation. When the facts started to come in from an extensive investigation, he had Lafreniere and his cohorts arrested, saying, "My earnest wish is that you may prove your innocence, and that I may set you free again."

He jailed five of the suspects; Villere happened to be out of town at his plantation. His story follows later.

Then O'Reilly did a clever thin. In a calm speech to a tense crowd, he pardoned the rest of the city for the uprising. This relieved a nervous

populace and isolated the rebels to just six miscreants. A state trial—what is known today as a grand jury—found Lafreniere and his five co-conspirators guilty of sedition and ordered them to be hanged. However, the only hangman in the territory was black, and despite the fact the defendants were found to be traitors, it would have been a disgrace to be hung by a person of color. So, for the want of a white man, the sentence was changed to death by firing squad.

On October 25, 1769, at the foot of Esplanade, where the New Orleans Mint stands today, the five Frenchmen were lined up and summarily gunned down by a firing squad. It was a bold, shocking, unthinkable ending for proper gentlemen in the Creole perception. But nobody messed with the governor after that, and even now, he is known by locals as "Bloody O'Reilly."

The delightful historian John Churchill Chase reports a story that the commander of the firing squad, a certain Capitan Jacinto Panis, years later, married the widow of the slain Milhet. He further goes on to cite a legend that the former Madame Milhet never knew her second husband had killed her first one.

When Villere returned to town, apparently to sue for pardon, he was immediately arrested and brought to a ship, which was used as his prison. The frustrated landowner, known for his temper, went ballistic in the ship/jail, and some accounts say he died of an apoplectic heart attack. Other accounts, which are doubtful, claim he was bayoneted in cold blood by Spanish soldiers.

Today, there is a plaque at the site of the execution in front of the New Orleans Mint, in two languages, that calls the executed men "patriots and martyrs." It also incorrectly states that Villere died before the execution. The largest park in suburban Metairie, next to New Orleans, was Lafreniere's plantation, and it bears his name today.

A more interesting name is the street that begins at the site of the execution, known as Frenchmen Street, named for the six men that died trying to keep Louisiana French. Today, Frenchmen Street is a raucous but cleaner alternative to Bourbon Street, with many clubs, an outdoor art market and food. Farther up on Frenchmen Street, about twenty blocks, is the location of the Old New Orleans Rum distillery, which we shall tour later.

"Bloody" O'Reilly would look dourly upon Frenchmen Street today, not only because of the name, but because of the rum-soaked revelry. O'Reilly thought New Orleans was too much of a party town (go figure) and closed a ton of bars and brothels. He only allowed twelve taverns and one lemonade stand. Not sure what was up with the lemonade stand, but he went further

by restricting prostitutes, thieves and other undesirables from going to the sanctioned taverns. Oh, and he also outlawed bad language. For a governor who was only in New Orleans for about six months, he certainly left his mark. To this day, there are only twelve bars in town, all of them clean and without immoral behavior, language or people. And a lemonade stand.

NEW SUGAR AND OLD HICKORY

Mo landan mo boutèy, mo pou ka sasé to tren; si to sasé mo, mo ka frapé to. Tafya.
I am in my bottle, I'm not looking for any quarrel; if you provoke me,
I'll knock you. Who am I? Tafia.
—French Creole proverb

I n the 1790s, everything was pretty groovy in New Orleans for a New World French aristocrat. There was coffee, silk, champagne and even opera. And then the worst thing in the world happened: Napoleon sold us to the Americans.

This is how it went down. President Thomas Jefferson was getting all these complaints from people out West. Out West in those days meant Ohio and Kentucky and other places along the Mississippi. And the entirety of our bounty from this brand-new growing country had to ship downriver out of New Orleans. American shippers had the so-called rights of deposit in New Orleans. The Spanish had granted American boatmen the rights to keep their products here until they could be shipped abroad and likewise with cargo coming in from overseas. Then the rights got suspiciously revoked. What folks did not know was Napoleon had secretly repossessed Louisiana from the Spanish with the promise that if he ever sold it, Spain would get first right of refusal—you know he would go to them first.

Americans lost their minds. The port masters were charging such outrageous fees for loading and unloading on the docks that the Americans were not making any money. In a way, this shows the importance of the

Barrels of molasses on the banks of Mississippi. *Courtesy of the Historic New Orleans Collection, acc. no. 2009.0170.*

port. The United States had all that great land in the North, but it was not as valuable without possessing a way out. And didn't the French know it.

When the Americans sniff out Napoleon's little deal, Jefferson sends a little committee to Paris to buy what he called "The Isle of Orleans." Bonaparte was literally in the bathtub, his daily routine for a skin disease he had, when the visiting Americans offered $5 million for just New Orleans. This sounded intriguing because France had land, albeit not very profitable, but needed money for another coming war with England.

The emperor basically tells them, "Give me 15 million and I'll give you the whole damn thing." Now there are many common retellings of this sale, but there are a couple of things people do not remember.

First, France already owed America $4 million from some earlier wartime debt, and to make up the rest of the $11 million, the Americans went to Barings Bank in London to float the bonds for the money. America gets the money and gives it to Napoleon, who then spends it on weapons to attack England. Thus, an early tale of the cycle of finance and military.

The other idea that is very popular among certain historians is how Napoleon squandered the great Midwest for just four cents an acre. How could he be so stupid? The reality is Napoleon was like a guy selling a camera

on a street. He had fewer than five ships in the whole of the Caribbean; whereas England had over twenty. He knew he could not hold on to the territory, so he got what he could for it. Indeed, just twelve years later, the British actually landed troops to take New Orleans.

More on that later.

As for poor Spain, Napoleon had promised to go to the Spanish first. How did he handle that awkward situation? Simple. He eventually forced King Carlos IV to abdicate and installed his older brother Joseph as the new king. Problem solved.

In any case, after the Louisiana Purchase, back here in Paris in the Swamps, where gentlemen planters and rich commodities brokers were walking the streets, a whole bunch of bearded buckskin-clad rednecks show up on the docks. The Creoles had very little contact with Americans, and soon they believed that all of America was peopled with gun-toting, crass buffoons. To be honest, some Frenchmen still think that.

These hardcore hayseeds were coming down from upriver on barges laden with northern produce, squirrel skins, bacon, cheese, corn, cotton, bear fat, Kentucky bourbon whiskey and other essentials they could sell. Then they would sell the boats themselves, which would be demolished and used for wood. There are still bargeboard houses in New Orleans today made from these boats.

Another thing they would do is change money. Paper money was relatively new. It would be printed by individuals—successful businesses and banks mostly. A thriving ironworks here, for example, would print money that could be redeemed for actual gold coin. Paper was accepted locally, but what happens when you go upriver to St. Louis and no one has heard of that faraway ironworks?

However, there existed an almost universal currency that was accepted from New Orleans to Chicago. It was money printed by La Banque Citoyen de Louisiane, Louisiana Citizens Bank. We were so economically strong here, people would come and trade all their assorted monies for tender from that bank.

Hang in there. This is a tangent, but it has got a cool ending.

The money Louisiana Citizens Bank printed was in French. The five livre note would have fives all over it and the word *cinq* printed in the middle. The most popular bill was the ten, which had *dix* written on it. Americans pronounced "dix" to rhyme with "six."

So, these guys were coming down the river to "get a bunch of them Dixies," hence the origin of the word *Dixie*. The famous song "Dixie" was

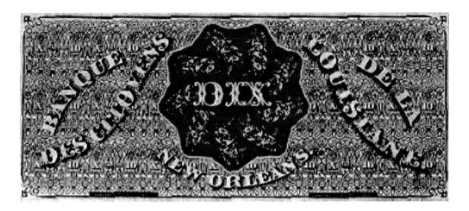

A dixie ten-livre note. *Author's photograph.*

composed just before the Civil War, and the term *Dixie* got applied to the entire Confederacy. It says "Heart of Dixie" on some Alabama license plates, but it ain't so. It's just Alabama. Dixie is here in New Orleans.

But back to the Kaintucks. They would buy rotgut with their profits. Good old local rum. Then they would get into fistfights on the docks, sleep it off, wake up the next day, walk back to Illinois from New Orleans and do it all over again. The horrified Frenchmen thought, "This is worse than the Spanish," and became even more provincial and closed off from outsiders.

These animals descended from a scary sounding place called Kentucky, and the locals closed ranks, basically shutting off the Kaintucks from the business side of town. The local part of town is still called the French Quarter. The Kaintucks had to make do on the other side of Canal Street, where the Jesuit plantation once sat. When they absolutely had to meet for business, the Americans and the Creoles would meet in the wide middle of Canal Street. To this day, New Orleanians do not say median or boulevard—they call the middle of a big street the "neutral ground." To use the term in a Carnival sense, you might hear, "Yeah doll, I'm on Float 6, on the neutral ground side." Very important information if you want to catch some good throws from your friend. In his book *The French Quarter*, Herbert Asbury writes the following:

> All of the inhabitants of the western country were known in New Orleans by the generic name of Kaintuck and were regarded as blustering barbarians whose presence could be tolerated only because of urgent economic necessity. To the Creole, Kaintuck was a hobgoblin with which to frighten children.

41

Ill behaved little boys and girls were told that the Kaintucks would get them,
and scolded their offspring thus: "Toi, tu n'es qu'un mauvais kaintuck."
("You're no worse than a Kaintuck.")

And a funny thing happened during all this acrimony. Everybody got rich! You remember Eli Whitney? He created a machine that made processing cotton easier. Soon, unimaginable stacks of cotton, floating down from Mississippi, Arkansas, Missouri and elsewhere, were piling up lucratively on our docks.

Even better, a former king's musketeer married into a well-landed Louisiana family. Etienne de Bore, a French nobleman, acquired part of the old Jesuit plantation. He grew indigo, a plant that makes blue dye, and was pulling in over $100,000 a season on his crop. However, a few years of bad luck decimated the crop. There are all sorts of explanations out there on what happened to de Bore's crop—insects, drought, worms, a virus. Whatever it was, Etienne de Bore was going to go belly up.

Remembering the Jesuits, de Bore planted sugar. He had two managers, Mendez and Lopez, refugees from the present-day Dominican Republic, where sugar grew abundantly. The two Santo Domingans had worked sugar all their lives in the old country. They were escaping the scathing Haitian Revolution and the horrifying massacres that ensued. The pair were so well-versed in sugar growing, the planter hired them.

De Bore and his managers worked tirelessly having diversion levees constructed along the Mississippi to irrigate his crop. Picture an army of slaves, knee-deep or more in muddy water, dumping bucket after bucket of rocks and mud to siphon off a precious bit of water from one of the strongest currents in the world.

De Bore built a sugar mill, a humble affair where the juice could be expressed and boiled down to syrup. De Bore needed this to work. In a world where rum could kill you, women were possessions and slavery was not frowned upon, the biggest disgrace was being a broke aristocrat. They put four years into the project and hoped they were not wasting their time.

The managers tried out an idea they had practiced back in the islands. They would allow the molasses to dry out on long drying tables. What resulted was perfect-for-Cheerios granules of sugar. Normally, sugarcane was made into a sticky, unwieldy syrup, molasses, and left at that. Here, they were turning sugar into, well, what we call sugar today. They became the first to granulate sugar on the continent. This meant no longer sending messy difficult casks of molasses abroad, which were heavy and could burst

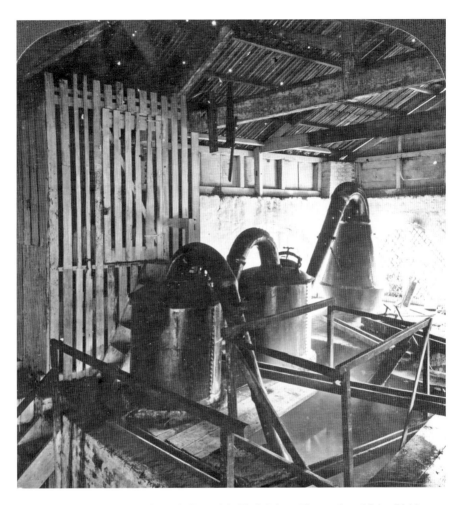

Jamaica rum still. *Schomburg Center for Research in Black Culture, Photographs and Prints Division, The New York Public Library. "The Still and Retorts for making Jamaica Rum in the Liquor Department of a Sugar Estate, Jamaica." New York Public Library Digital Collections. Accessed January 17, 2019. http://digitalcollections.nypl.org/items/5e66b3e8-9a8a-d471-e040-e00a180654d7.*

open and contaminate the cargo. Sugar just tastes better, and it had a longer shelf life. Best of all, everyone likes sugar! De Bore made $12,000 his first year. Soon, that sum would be a lot more. And de Bore became the first mayor of New Orleans.

The product took off. Most indigo plantations switched to sugar, and an industry was born. Today, as mentioned, 400,000 acres of Louisiana grows sugar. In 1994, the 200th anniversary of de Bore's breakthrough, over a million tons of sugar was produced here.

Sugar was so profitable, de Bore quit being mayor after less than two years to go back to the plantation. His grandson, Charles Gayarre, was a historian, and his work contributed to this book. Etienne de Bore's final resting place can be seen in the prestigious St. Louis Cemetery No. 1.

So by the time we become American, we have a growing lucrative industry, American products from upriver flooding into the city and a New Orleans economy that looks poised to grow. But not just yet. Remember how Napoleon used his Louisiana Purchase money to fight the British in another war? Well, we were American now and kind of their enemies and the English were not going to let France get any of that good stuff out of America, so they blockaded us. Too quote an old punk song you have probably never heard, "Let's Have a War!"

Here's the thing a lot of history teachers do not bring up about the War of 1812: We were losing.

Yes, America was upset about the British messing with our shipping and our sailors, but nobody wanted to fight. In New England, everyone thought President Madison just wanted the war to steal Canada. We lost in Detroit, and shortly thereafter, we suffered a brutal massacre near there. There were protests against the war in Baltimore. We were repelled from Canada. Then the British landed in Washington and burned the White House down. It had been thirty something years since independence, and there was a real possibility we would be reabsorbed into the empire.

Andrew Jackson had gone to Madison looking for men to go to New Orleans. He had been on and off indirectly fighting the British during his Indian Wars. As a boy, he witnessed the devastation the British army wrought upon his native Carolina; his brothers and mother died in the American Revolution, and at thirteen, he was a prisoner of war. He famously refused to polish a British officer's boots during his imprisonment, and the officer flicked his sword across the boy's face, leaving an obvious scar the rest of his life. The scar has been photoshopped out on the twenty-dollar bill. Few people hated and distrusted the British as much as Jackson. Militarily, he reasoned the easiest way to choke America was to grab New Orleans. He knew any invasion would ultimately come to the port.

Madison, probably caring more about grabbing Canada, basically said, "I can't help you." So being a self-starter, Jackson gathered his own men out of Tennessee and Kentucky, went down to New Orleans where he united the wary Frenchmen, men of color, Native Americans and even cut some mysterious deal with the local pirates to get some men. More importantly, the pirates hooked him up with cannons. He came into town well prepared

and reassured the locals he was not going to burn the city down. He made sure to meet with civic leaders of every community. Remember, Jackson was technically a Kaintuck.

These series of meetings took place in the present-day French Quarter—Mayor Girod's house (today, it is the Napoleon House), Edward Livingston's house (108 Royal Street), a tavern (Original Pierre Maspero's) and at a house at Royal and St Peter's Streets. In the scant paperwork and delivery receipts from some of these meetings, rum figures as much as just about all the other necessaries put together. Jackson was not a heavy drinking man, as he was often sick from his many maladies from duels and fighting in the wilderness, but he did take a whiskey every now and then—very often rum.

So, after a series of skirmishes in the surrounding swamps, on January 8, 1815, the final face-off between the Brits and Yanks was set. On the east bank of the Mississippi, six miles downriver, Jackson had created a rampart behind a canal with cannons evenly spaced. To his right was the river, to the left, a thick swamp. His 2,800 men, often correctly called "ragtag," were expecting 8,000 seasoned British troops.

Jackson stationed the Native Americans in the swamp to force the Redcoats back to the open area toward the river. The riflemen crouched down four deep behind the rampart. It took forever to load a rifle back then, so the idea was the first guy would fire, round to the back while reloading, then the next guy would fire, then the next and so on, creating a constant volley of bullets. The pirate cannons helped a lot.

For the English, ESPN might have said they did not execute their game plan very well. Being veterans of the Napoleonic Wars back in the widespread fields of central Europe, they were used to marching in grand ranks toward the enemy. This tactic proved to be fatal in the narrow riverside corridor.

Additionally, the first wave of attack was supposed to carry ladders and bundles of sticks to throw into the canal. The next wave would then clamber over the ladders and sticks to engage with the Americans atop the rampart. But, in the early morning fog, worn down by a month of fighting in a chilly, wet swamp, the attackers forgot to take the ladders and sticks.

Halfway to the rampart, the battalion turned heel to get the ladders and sticks and suffered 500 casualties in the first minutes of the battle. It got worse after that; three of the four generals were killed, including Edward Pakenham, brother-in-law to the Duke of Wellington, the victor at Waterloo.

At day's end, the British lost anywhere from nine hundred to three thousand men, depending on which source you want to trust. The Americans lost thirteen.

The shock and joy of us pulling victory from defeat reverberated internationally. Domestically, Americans, for the first time, felt a more confident sense of patriotism; there was never a battle against a foreign enemy on American soil again, and Andrew Jackson, the savior of New Orleans, would be a two-term president.

Now there are many who point out that the war was actually over when the battle was fought, which is true. The Treaty of Ghent was signed two weeks before, but no one knew it yet. But think about it. Had the British carried the day, do you think some referee would come out NFL-style with headphones announcing, "Upon further review, Americans retain possession of New Orleans?" In all likelihood, by the time the news hit home, all of the Mississippi Valley would be in British control, and they would be knocking on the door of St. Louis. The more we examine the Battle of New Orleans, the more miraculous it seems.

Today, most American states have a town named Jackson or Jacksonville. New Orleans has Jackson Avenue, Jackson Square, Andrew Jackson High School, etc. And Madison, the guy who would not help us out? He gets an empty, dirty, little alley in the French Quarter.

And what about rum? What does our fine spirit have to do with the greatest military miracle in our history? Well, remember poor General Pakenham? It was necessary to preserve his remains to be buried at the family castle back in jolly ol' England, so for the return trip, he was sealed up in a cask of rum.

YO HO HO AND A BOTTLE OF BRANDY

"American soldiers arrest my men,
French juries acquit them."
—Supposedly said by Jean Lafitte, but I doubt it

"We got a barrel of rum for you from Thibodeau's," said Jean Lafitte.
"No you ain't," said a sleepy voice.
—Also not said by Jean Lafitte but from one of many nineteenth-century
adventure stories about him

So with America's growing wealth flowing through the city and the establishment of Creole and American business booming in the Crescent City, we experienced a Golden Age. By 1840, New Orleans was the third-largest city in the country and the richest. Of course, where there is money there are also those who want as much of it as possible.

These included notorious river boatmen such as Mike Fink, who probably never came here but is the legendary avatar of the rapacious river thieves. He worked ostensibly as a river scout and was a certifiable sociopath who drank, gambled and picked fights with anyone who crossed his path. Oh and by the way, Fink complained that "rum ruined [his] stomach."

He and his posse worked the rivers of middle America. When they docked, they would seek out fights with the toughest of the locals. The prize, so the story goes, was a red feather. Legend tells us Fink had a war bonnet of red feathers. He and his vile pals thought it was fun to shoot mugs of rum

out of each other's hands and stuff. This hobby literally backfired, as finally, shooting at a mug of something (I like to think rum) off his best friend's head, his aim was low and he killed his friend. A second friend, clearly put out by the accident, grabbed the dead friend's pistol and shot revenge into Fink's head.

Less than a decade after the battle, keelboats trafficked the rivers. A keelboat, larger than a flatboat with a sturdy keel to withstand collisions, usually furled a sail. The outfitted keelboat with storied crews of five or six brutes battled the Mississippi with poles, hooks, oars, towropes and sails. They proudly declared themselves "half-horse, half alligator." An upriver and downriver trip could take months. Ralph Andrist writes in *Steamboats on the Mississippi*: "They were always troublesome in New Orleans when their long journey ended and they had money in their pockets and nothing to do but enjoy themselves. They liked to wreck respectable restaurants and theaters, and bands of them often engaged in wild battles."

After these ruffians sold off their cargo, they had big money. Most times, it was so difficult to drag the rivercraft back north, boatmen would simply demolish the boats and sell the wood to supply-strapped New Orleans builders. When walking the old neighborhoods of town, look for bargeboard doors and window trims. Many house frames in these areas are poplar. Poplar grows about two hundred miles upriver from New Orleans, which is how folks tell if they have original bargeboards as part of their homes. Real estate listings still brag about "stunning bargeboard" cottages and accoutrements.

Keeping whatever profits they did not guzzle, these rugged businessmen would literally walk back as far as Chicago.

But now the script flipped, and these aggressive river rats were now the prey. Murderous highwaymen awaited these gold-laden mariners. The east bank route upriver from Natchez, Mississippi, to Nashville, Tennessee, the so-called Natchez Trace, merited the moniker "The Devil's Backbone."

And the parade of vice continues. When New Orleans became American in 1803, there were more gambling houses than in Baltimore, Philadelphia, Boston and New York combined. On the river, hundreds of gambling boats flourished, though it was pretty much accepted that they cheated. Like with public drinking today, New Orleans was exempt from the anti-gambling law that stood for the rest of the Louisiana Territory. For real, the city council had to pass a law outlawing gambling during church services. George Devol writes in *Forty Years a Gambler on the Mississippi*:

I took passage on a steamer that had nearly 300 people on board…and, of course, they had plenty of money with them. After supper tables were cleared, a game of poker was commenced; then another, and another, until there were five tables going. I sat at one of the tables looking on for a long time, until at length one of the gentlemen said to me, "Do you ever indulge?" I said, "Hardly ever, but I do not care if I play a while." The bar was open, and they all appeared to enjoy a good drink, but I never cared for anything stronger than a lemonade. The result was that they all got full, and I thought I might as well have some of their money as to let the barkeeper have it, and I commenced to try some of the tricks I had learned. I found they worked finely, and at daybreak the bar and I had all the money. I got about $1,300 [$36,000 today].

There were no gambling boats in the nineteenth century like we have today. The itinerant gamblers would board a ship, conspire with the captain and cut him in on the take. Some captains were cool with it, and some were definitely not. When a gamer ticked off a captain, he would enjoy a wet return to shore. In this way, cardsharps took advantage of the planters/merchants delivering cargo to New Orleans on their way home with their freshly earned income in hand.

George Devol, self-proclaimed "King of the Riverboat Gamblers," started his predations in New Orleans at the age of seventeen. He wrote that he had an inordinately thick skull. No kidding, doctors told him it was an inch thicker than normal. Experience agreed. "I have been struck some terrible blows with iron dray-pins, pokers, clubs, stone-coal and bowlders [*sic*]," he either lamented or boasted. Some chroniclers claim he bilked over $2 million in his life (in today's money). However, despite the slings and boulders of outrageous fortune (in his favor), he died penniless in Arkansas.

The city also hosted a bevy of brothels across town. Decades before Storyville, rich landowners would outfit a house as a bordello, making easy money off the flesh of the many unfortunate women who found themselves trapped in the sex industry. These places would serve up cheap beer and cheap rum as customers would smoke cigars, talk with the girls and then disappear upstairs for twenty minutes. These were not organized or even public; they were sort of Airbnb speakeasies.

The omnipresent bordellos drove down property values and supplied no income to the city. And if one was exposed, the owners—rich, powerful guys—would influence the authorities to charge a token fine or forget the whole thing. Prosecutors were so frustrated at the lenient penalties, they

often dropped cases against the women and owners. Years later, the city actually created a red-light district to fix these issues, but that was later on.

The most infamous of the ladies of questionable morals in the early days was Delia Swift, also known as Bridget Fury because of her flaming red hair. Fury had escaped prison in Ohio to come to charming New Orleans, where she found rich pickings. She did not work out of some shady bordello; she freestyled in the finer venues of the city. She would meet a gentleman and escalate the date to lubrication—she was fond of rum-drinking contests with her companion. Rum, being clear, could be easily subbed for water. She would turn a trick, get a little money. Then once her clients were de-moneyed, plastered and vulnerable, she would stick a knife in them. Bridget Fury gored dozens of men, some of them dying. One of her victims, on his deathbed, refused to press a charge because he felt he "deserved to die being of no good to the world." Finally, Fury got sent up to prison, where after a year and a half, in the good graces of officials, the warden wrote a glowing character evaluation. She was released early, but her prostitution and her rampage of stabbing her victims went on for years.

Even more despicable than the boatmen, casino owners and hookers were the avaricious politicians. The words "corrupt" and "government" have always been interchangeable around here. Here is a common newspaper item, a satirical poem about how "good" the government is (note how rum is used as a metaphor for debauchery):

> *How goes the money? Come,*
> *I know it doesn't go for rum*
> *It goes for schools and sabbath chimes*
> *It goes for charities sometimes*
> *For missions and such things as those*
> *And that's the way the money goes*
>
> *How goes the money? There,*
> *I'm out of patience I declare*
> *It goes for plays and diamond pins*
> *Public alms and private sins*
> *For hollow shams and silly shows*
> *And that's the way the money goes.*

With a closed Creole society looking after their own and American public officials charged with policing the most important port in North

America, there was a real breakdown in the execution and maintenance of order. It became pretty clear to unscrupulous businessmen that with these inefficiencies, corners could be cut. With this array of vice and laissez-faire attitudes, it makes perfect sense that the city would become a hub for piracy.

A few years before the War of 1812, President Jefferson did a dumb thing. He wanted to punish France and England for letting their eternal wars spill over into American affairs. Our ships were being boarded, sometimes commandeered, and supplies were taken. Jefferson declared an embargo against those nations. Think about it for a second. We were a young country, still growing in world finance; and now we are cutting ourselves from our richest options. I know, right?

It almost ruined the American economy. "Ograbme" is embargo spelled backwards, and many newspapers and broadsides decried it as such. The embargo meant we could not sell to France and England, and we could not buy from them. No coffee, no silk, no candied figs. And no rum! We could not sell our sugar, and we could not import the good stuff. There is a famous political cartoon of a guy trying to make off with a barrel of rum from an anchored British ship and a large snapping turtle with "Ograbme" blazoned on its shell biting him in the backside.

In a wretched hive of scum and villainy like New Orleans, guess how that was going to go down? Of course, folks came forward who would oblige locals with those essential niceties. Most notable of these pirates were Pierre and Jean Lafitte. They were from San Domingue (today's Haiti). No, they were from Burgundy in France. No, they were from St. Malo. Or was it Brest? No, they were Sephardic Jews from some other place. And Jean died in Honduras. No, he died in Cuba. No, Venezuela. No, he was stabbed by Bridget Fury in the French Quarter. You get the idea.

Some of the few actual things we know is Jean Lafitte was a real person and really did own property in and around New Orleans. He really had a secret base of operations down on the Gulf in Barataria Bay, on Grand Terre Island, which is long gone now from a later hurricane. Many descendants of his crew, and possibly himself, live on the still-surviving neighbor of the pirate island—Grand Isle. At any given time, he would have several ships (some say seven, some say fifty), a few hundred men (some say a thousand), stashes of contraband—cheeses, wines, medicines, weapons, tools, silk, candied figs, spices and rum, naturally. He had his own security force. Lafitte supposedly bragged that it was safer for a lady to walk down the road in Barataria than in the city of New Orleans.

Pirates unloading rum to trade for slaves. *Ellms, Charles. The Pirates Own Book. Urbana, IL: Project Gutenberg. Retrieved January 16, 2018, from https://www.gutenberg.org/files/12216.*

Lafitte carried so-called letters of marque from Cartagena in Colombia. This meant he was not a pirate but a privateer, an actual businessman accepted in countries that were enemies of his prey. Despite the semantics, it is hard to distinguish between a pirate and a privateer. At the time, it seemed okay in America to steal from the despised British and reward the perpetrator with the profit from the attack.

Adding to these Baratarians' business opportunities, the United States outlawed slave importation in 1808. Slavers could still sell people already here, they just could not import any new ones. The pirates would identify slave boats, steal them and take the slaves, sometimes giving the boats back to the original crew. Then they would land outside the area and march the slaves into New Orleans, claiming them as domestic slaves. They made big bucks. One haul netted Lafitte $15,000 at a time when $1,200 could buy a really nice house.

The pirates were tolerated by a French and American population who wanted finer things. And as they had helped out in the Battle of New Orleans, they were kind of rogue heroes. President Madison pardoned them for any previous crimes. Local authorities dropped all charges. The pirates would set-up tables alongside St. Louis Cathedral on Sundays after Mass to sell their quasi-legal goods, including rum. The alley next to the church is still called Pirates Alley today. For weapons or a slave, they would collect their fee and give a receipt that could be remitted at a more discreet time and location.

One location might have been an old forge, which today is a bar called Lafitte's Blacksmith Shop, that the brothers may or may not have owned. Some claim it is the oldest bar in America; sadly, it is not, but the venue brings you back to the eighteenth century. Inside, you sit beneath giant exposed wooden beams. The walls are a rare example of briquette-entre-poteau walls, cypress beam framing stuffed with mud, Spanish moss, horsehair or anything that could serve as drywall. The bar is always packed in the evenings, and the bartenders might be the quickest in the French Quarter. Additionally, they offer the voodoo daiquiri (think of a grape popsicle smooshed into 151 rum), which will take you back to any century you want.

There is no doubt that the pirates sold illicit rum; however, there is also evidence that rum was used to pay for the pirates' booty, not only contraband but for the slaves themselves. For example, a dark cartoon from a newspaper of the time shows a white man making off with an illegal slave on the levee, while a sketchy pirate makes off with casks of rum.

You are what you drink in Old New Orleans. The French Creoles drank brandy; rich Americans preferred Madeira. The dreaded Kaintucks from upriver brought their whiskey. But everyone else—the poorer folks, sailors, dockworkers and vagabonds drank the cheapest stuff—rum. Besides, rum in New Orleans was indicative of the Caribbean character of many of the natives here. It is reputed that a lot of Pierre Lafitte's crew were islanders. He may have been one himself.

Lafitte's blacksmith shop. *Historic American Buildings Survey, Creator, Pierre "Lafittes," and Jean "Lafittes." 941 Bourbon Street Cottage, New Orleans, Orleans Parish, LA. Louisiana New Orleans Parish, 1933. Documentation Compiled After. Photograph. https://www.loc.gov/item/la0018.*

Pierre Lafitte seemed to not like the hands-on work of piracy. A popular story here has him ending up living upriver with a proper wife and wanting to pretend to be a gentleman. Probably putting him off more, a hurricane swept the Baratarians out of their headquarters.

Ever on the lookout for more power and money, Jean Lafitte discovered a new job in Galveston as a spy for the Spanish. In 1817, he moved there, took over and made everyone take loyalty oaths to him and basically created his own city-state. Lafitte spied for both sides. He also kept up his predations, and many barrels of rum, guns and slaves passed through this new deviant enclave. There was an update of the Act Prohibiting Importation of Slaves in 1818, which contained a mouthwatering loophole for the pirate. It was technically legal to capture a slave ship. Despite a setback due to the weather in 1818, Lafitte was soon an all-in slaver, making bank and guaranteeing thousands of souls a life in chains.

It is hard to deny that Lafitte proved to be a hero during the Battle of New Orleans. It is also easy to see that he opportunistically chose the side he

figured would win, and would have the most to gain from. Additionally, it is said, though not documented, that he attacked over a hundred ships. The execution of such operations could not have been a pretty sight. He skirted laws to unload his stolen goods. It is documented he marched enslaved people from Texas to Louisiana, where he would keep them in outdoor pens and then sell them by the pound. The scant verified quotes and stories about him all point to a greedy, rabbit-eared, sociopathic prima donna. It is reasonable to wonder if history will turn less and less kind to him.

Nevertheless, the swashbuckling buccaneer anti-hero image remains. In this region, we have a Lafitte Street, a Lafitte bike path, tons of bars and hotels featuring some version of the name, Lafitte National Park and a town of Lafitte. There is a Jean Lafitte Society out of Galveston. Full disclosure, this author occasionally puts on a sword and plays the notorious pirate for special events.

And Lake Charles has a sixty-year-old festival called Contraband Days, which very recently changed its name to the Louisiana Pirate Festival, perhaps in deference to the idea that contraband included humans and to back off Lafitte a bit. The celebration features a series of events over ten days, including a trial of the mayor that always ends in his or her being sentenced to walk the plank, which they do. And of course, among the rides, parades, cooking expos, costume contests and every other family-friendly debauchery, lots and lots of rum flows.

DEMON RUM, ARMY OF ANGELS

Rum may be very harmless in a hogs-head,
but by all means should be kept out of other people's heads
—Aphorism in the New Orleans Times-Picayune, *1837*

The Civil War proved to be frightening, angry, violent and tragic, and for New Orleans, it was damned inconvenient. There was no battle here; in fact, many of the men were off fighting elsewhere. Then President Lincoln sent fifteen thousand men, twenty-four gunboats and nineteen mortar boats up the river. After bombarding two forts way downriver, the Northerners entered the city without a shot.

And without a shot of rum. A withering Union blockade kept us almost free of rum, as well as food, medicine, manufactured goods and luxury items. England did not want the hassle of running afoul of the U.S. Navy, so it seldom tried a Southern port, including New Orleans. Coffee, always a staple here in the Golden Crescent, suddenly disappeared from shelves. In order to stretch supplies, locals here would add chicory, the bitter root of the endive plant. Though this started as a response to a dire need, it is now a signature delicacy. If modern visitors want a real New Orleans specialty, they can sample chicory coffee with scalded milk—café au lait.

The Union soldiers turned out to be disrespectful and probably horrified at the dissipation they found among the citizens in laissez-faire New Orleans. Soldiers, and horses, occupied the abandoned mansions of those rich enough to go elsewhere for the duration. Fugitive slaves were given their freedom as "contraband of war," further outraging citizens.

General Winfield Scott's disparaging view of the Confederate cause. *Elliott, J.B. Scott's great snake. Entered according to Act of Congress in the year. [S.l, 1861] Map. https://www.loc.gov/item/99447020/.*

Provisional governor General Benjamin Butler daily dealt with locals acting up against his rules and his men. It did not help that he was a Jew-baiting, self-enriching, bungling leader, an outsider in a town of diverse folks. New Orleanians felt they were being treated like second-class citizens by fourth-class people. People often spat at and insulted the soldiers. A local lady of means slapped one of Butler's officers in broad daylight. Butler was given the derogatory nickname "Beast" and, more hilarious, "Spoons" because folks said he would steal the silverware at a dinner for the Union cause.

It got so bad, a frustrated Spoons Butler had an Andrew Jackson quote carved into the pediment of our precious equestrian Jackson statue at the center of Jackson Square: "The Union Must And Shall Be Preserved." Additionally, he declared a law that any woman dissing a Union soldier would be arrested as a prostitute. This provoked outrage as far away as

Europe. Finally, he had a local Confederate sympathizer hanged for tearing an American flag off the New Orleans Mint, the very spot where Bloody O'Reilly's execution took place.

The roots of this moral superiority come from the zeitgeist of the nation itself. Think about it. Our previous wars were for freedom—the Revolution or the War of 1812—or for a vague imperialism—the Mexican-American War. These wars focused on a foreign "other." But now, this war against our own people, was a moral cause. The nation, on both sides, began to look at issues of humanity, what makes a person a person and what does America stand for. Whereas earlier newspapers contained mostly business, political and advertising news, there now appeared more and more tongue-clucking and moral outrage.

In a diary entry, a young New Orleans girl deplored the fact that the Confederate army was not around to protect the city and refers to the Union soldiers as "vandal hordes." The locals truly thought they were being occupied by a foreign enemy, not fellow Americans.

On the other hand, uptight, hyper-religious Northern boys experienced the South, and New Orleans, for the first time. Surely all they saw was sin. Mardi Gras must have freaked them out. And it went beyond just slavery. Even in those antebellum days, public drinking was still kind of bragged about. In a Union soldier's letter home, he refers to the locals as "the rabble." And this influx of "American-ness" slowly started to change attitudes. The days of the erect Creole haughtily walking the French-speaking streets following his own ethics and not caring for the judgements of others were waning. Now judgement was a big part of the national attention.

For example, after the war, alcohol abuse—though it was not called that then—came into the crosshairs of societal judgement. Today, many think of the "Drys," the anti-alcohol societies, as dour-faced women, fun-killers chopping their axes into precious barrels of rum. But there is much evidence that alcoholism and drug abuse raged through the country.

The rummy reputation of New Orleans reached across the sea, even in these times. In 1859, composer Francisco Ansejo Babieri created a musical piece called *Entre mi mujer y el negro* (which translates to "Between My Wife and the Black Guy"). Provocative title in any age but expected here, for the piece was a zarzuela—a roguish musical operetta with spoken scenes. There was a new musical movement in Spain to "Spanish" up classical musical away from the French and Italian styles, and with this burgeoning came edgy themes, characters and places—in this case, the place was New Orleans.

The show focuses on two couples, one very definitely Cuban (i.e., more like the Old Country) and the other couple corrupted in debauched Nueva Orleáns. The noble character is Dona Inez, and the local is Miss Fanny. The show opens with the gentleman husband getting off the boat from Cuba and praising the rum here. Already, misbehavior lurks. Miss Fanny is called "butch" and "feminist" and other horrible insults and is shown throwing down a rum or two. And the husbands try to steal each other's wives. Yet again here, it shows rum as an evil thing.

Ostensibly the piece is political, racial and higher-minded than portrayed here, but it is interesting to note, that in the very year that the transatlantic cable is finished, New Orleans's decadent reputation for intemperance, immorality and, oh yeah, rum had already made it to foreign shores.

In the early colonies, everyone, even children, drank because life was rugged, water was often unhealthy, alcohol was vaguely medicinal and in a preindustrial society, dad or mom could sleep it off in one day and not lose too much. Not that alcohol was the symbol of safety; unscrupulous distillers might add benign "extras"—water, prune juice, glycerin or snake blood—to their concoctions to cut corners and make an extra buck. But there were also cases of more insidious ingredients—grain alcohol, sulfuric acid and even kerosene.

Nonetheless in 1830, Americans over the age of 15 were drinking seven and a half gallons of alcohol a year. Spousal abuse and family abandonment were through the roof. And many who did stay home and did not hurt their family, simply drank away the rent. It is interesting that Huckleberry Finn is set in this time. A child victim of an abusive alcoholic father has to fake his own death and escape with the lowest of society—the escaped slave Jim, who is to be sold in New Orleans—down the Mississippi, the heart of a growing country. It was not until the 1870s that American courts universally rejected "physical discipline" against a spouse. The push for prohibition was born out of a cry to save families.

In the media, rum drinking either was held up for the funny "town drunk" things people did, or rum became shorthand for depravity and low character. "The first municipal council met last evening, but there not being rum present, the meeting adjourned," stated the *Times-Picayune*, the joke being there was a goof on "no *quorum* present."

Another snippet from the paper, probably apocryphal, read that a gentleman asked for a room at a guesthouse with four beds because he admitted he came home so "full of rum" that he wanted to be able to find at least one of them. Or the three bad fourteen-year-old boys who chewed

tobacco, stole six dollars from a boarding house and absquatulated (yes that is a word), drank rum and slept on the levee on cotton bales.

But there are also articles that act as morality tales. There is the sad story of a little girl accidentally drinking her drunk daddy's rum and dying from it. And another about the mother so rum-soaked she neglected her children and got a month at the workhouse. These are quick, less-than-two-inch snippets, where the names of the protagonists are not even supplied. It is as if in the waves of news, dispatches and other worldly reports in the journals of the time, these served as a sort of Greek chorus reminding the reader of an insidious character flaw in the nation.

The story of the drunken mother appeared on the same page as an advertisement for White Ribbon Remedy, sold by the Woman's Christian Temperance Union, which could be added to coffee without the patient's knowledge to cure alcoholism. It was a mix of milk, sugar and ammonium chloride. There was an explosion of anti-alcoholism products like White Ribbon. Gloria Tonic was milk, sugar and cornstarch. The Infallible Drink Cure was mostly sugar, with a pinch of salt. Potassium chlorate, which today is used in making fireworks and matches among other things, appeared in some products and killed people.

So while there was a growing outrage at drinking, there was also a market demand for liquor. It had to be a lot like today's gun rights arguments on both sides. Though there is clear menace, there is also a viable market. Contemporary newspapers featured several advertisements bragging about imported rum for sale—a particularly fine one for $13.50 a gallon. Plagge & Co., on St. Charles Avenue, had daily advertisements for its locally produced rum. Probably because of the blockade, more and more plantations in the New Orleans area started distilling their own rum. This explains the many requests by new arrivals claiming "knowledge of Jamaican rum making" and looking for "a situation" on a local plantation as distiller and possible overseer.

Also, many failed plantations after the war were forced into selling off rum-distilling supplies, including one large concern offering a twenty-five horsepower steam engine, a triple still and thirty cisterns holding 1,400 gallons, rectifying tubes and more.

There was a bit of good news for New Orleans's rum-makers. Some doctors in Europe "discovered" that rum mixed with tea was a cure for cholera. Rum exports to France skyrocketed; one store in Paris sold 900 puncheons, 84 gallons, of New Orleans rum in a week.

The news did not stay good. In 1868, Congress cracked down and required distilleries to get bonded, pay taxes and outline specifically proscribed locations, such as boats, dwellings, tool sheds, etc.—all places where home brews might be hidden.

After the Civil War, the temperance movement gathered steam, along with suffrage—the first cry for gender equality—and an amazing national mania in healthy eating. Masticating societies appeared where folks would meet and eat. Famous names, including Kellogg (as in the Corn Flakes company) and Graham (as in the cracker) were actual people leading healthful diet campaigns. The fitness movement of the latter century rivals any New Age fad of today.

Clearly there were still many that enjoyed their rum, but the rising emphasis on morality, health and religion put all vices on notice. To cast it in religious terms, rum-making, along with all other production of liquor, which had raged into the nineteenth century as a celebration of the Edenic quality of New Orleans, limps out of the century with a sort of mark of Cain.

PROHIBITION...WELL, SORT OF

I've stood on my own feet, and I'm ashamed of nothing.
I'll never take a husband to boss me.
But I've got plenty of offers—
from a whiskered Count to common sailors in Nassau.
—Gertrude "Cleo" Lythgoe, Queen of the Rumrunners

Gertrude Lythgoe, called Cleo after Cleopatra because of her stature and beauty, ran rum out of the Bahamas to Florida during Prohibition. As she was in the news a lot, this gun-toting "Queen of Rum Row" had a bunch of nicknames involving "queen": "Bahama Queen," "Queen of the Bootleggers" and other variations. Once, some guy in a barbershop was sharing his disdain for alcohol and those that profited off of it. Cleo dragged him out of the shop, lathered and all, and at gunpoint "corrected" his worldview on her profession. He got off with a threat and not a bullet.

The "Queen" was a stenographer in England when she figured she could make better money smuggling hooch. Despite her illicit activities, she was pretty well known, even attaining the respect of her male competitors. Famous bootlegger Billy McCoy marveled at her "breathtaking fury." In her most famous arrest, she had to face trial in New Orleans for two thousand cases of illegal liquor. Her defense was that the booze was indeed hers, but two rat sailors stole them from *her*. She then testified against the sailors. She beat the rap.

The scourge of the Temperance Movement, a "hatchetation" is shown in progress here. Carole. "Carry Nation and Her Hatchet." AwesomeStories.com. Oct 07, 2013. January 17, 2019. http://www.awesomestories. com/asset/view/Carry-Nation-and-Her-Hatchet.

Cleo believed a "jinx" would eventually get her and quit the business, wanting to "beat the jinx before it got me." She died at eighty-six in California; and in her honor, the flags in Nassau flew at half-mast.

A lot of black-market rum ended up in the Crescent City, where, in the words of wonderful historian Sally Asher, "Prohibition was more of a suggestion than a law." On July 1, 1919, the sale of alcoholic beverages was no longer allowed. At the time, New Orleans was home to some 5,000 bars.

The mounting fervor toward Prohibition had been building for decades. Carrie Amelia Nation had become a veritable symbol for temperance. One of the most notable crusaders against liquor, Nation also campaigned against the wearing of corsets, as they damaged women's bodies. She called herself "a bulldog running at the heels of Jesus, barking at whatever He doesn't like."

In 1907, Nation herself called New Orleans "a wicked city" and promised to come here to harass saloons with her "hatchetations." A hatchetation was a charming exercise where Carry (she changed her name to Carry A. Nation) and her minions would walk into a bar and hatchet the booze

barrels, glassware and everything else. She did come to New Orleans, but luckily for local drinkers, she was only in the train station waiting for a connection and conducting a newspaper interview. She never made it to the French Quarter.

When World War I soured Americans on all things German, including breweries, anti-drinking groups claimed that grain was needed for the war effort. Congress passed a wartime law stopping the sale of liquor and beer. Shortly thereafter, the Eighteenth Amendment made that a permanent law.

Despite many dry parishes around the city, New Orleans remained staunchly wet. Mayor Martin Behrmann led protest parades and said, "You can make it illegal, but you can't make it unpopular." Hoteliers, restaurateurs, and bar owners all had hoped for a last-minute reprieve, but it never came, and the hated law went through. Enterprising locals broke it daily.

Antoine's, the oldest and perhaps most famous restaurant in New Orleans, had a "Mystery Room"—as in "Where did you get that coffee mug of rum?" And the enigmatic answer would be: "It's a Mystery to me." The entrance was through the ladies' room. Franklin D. Roosevelt once had dinner in the room (after Prohibition, of course), and it is still called the Mystery Room. The Grunewald Hotel, today's Roosevelt, had The Cave in its basement, a giant jazz club with cardboard stalactites dripping down, dancing girls and lots to drink. Some folks, like "Uncle" Joe Impastato at the Napoleon House, had secret taps. Others, like Tujague's, had their waiters carry bottles in their aprons. Pat O'Brien's, Galatoire's and Arnaud's all operated speakeasies in the French Quarter. Even stately Commander's Palace in the snobby Garden District got raided in 1921!

More than just the local businesses got into purveying. Many regular citizens decided to subvert the financial hard times by home distilling. Ladies would make beer in the kitchen. Struggling couples with large families sold illegal hooch. Many sad stories of desperate people resorting to breaking the unpopular law to subsist were reported almost daily in the papers, which made a point of publishing their names. In one case, an eighty-three-year-old woman was sent to jail for fifteen months for making wine in her house for her sick husband.

In an article entitled "Student in Rum Charges Granted Probation Plea," it was reported that Leo Bruno was allowed by the court to finish his Tulane studies after officers apprehended him selling rum to students at the corner of St. Charles Avenue and Broadway Street out of his car. Bruno assured the court he had "learned his lesson" and "there's nothing in the liquor racket." He got five years' probation. A year later, when Prohibition finally ended,

Above: The party spot for two centuries—Pat O'Brien's. *Photograph by Stephen Charles Nicholson.*

Right: King Creole, twenty years old, the highest-rated rum in the land. *Photograph by Stephen Charles Nicholson.*

From left to right:
Sweet(er) Tea, iced tea and spiced rum; Rum and Cola; Here, it can be called a NOjito; Honey Nut Cheerios Milk Punch, from Laura Bellucci at SoBou. *Photographs by Stephen Charles Nicholson.*

Above: A flight of rums from the Rum House. Try to catch $2 Taco Tuesday at the Rum House. *Photograph by Stephen Charles Nicholson.*

Left: The ingredients you need to make a Sandy Bottoms (see "Rum Recipes"). *Photograph by Stephen Charles Nicholson.*

One of James Michalopoulos's classic "melting" houses of New Orleans—some of the houses actually look exactly like the paintings. *Courtesy of the Michalopoulos Gallery.*

Above: The awesome bar at Tujague's. *Photograph by Stephen Charles Nicholson.*

Left: Tools of the trade. *Photograph by Stephen Charles Nicholson.*

Right: The second-oldest restaurant in the city—170 years and counting. *Photograph by Stephen Charles Nicholson.*

Below: Arrgh! at Pirates Alley Café. *Photograph by Stephen Charles Nicholson.*

Above and opposite: Pirates Alley Café knows a thing or two about rum. *Photographs by Stephen Charles Nicholson.*

Right: Denzel Brown at Atchafalaya Restaurant Uptown. *Photograph by Stephen Charles Nicholson.*

Below: Bananas Foster French Toast, from Stanley Diner on Jackson Square. *Photograph by Stephen Charles Nicholson.*

Left: Dré Glass at Pearl Wine Company. *Photograph by Stephen Charles Nicholson.*

Below: What you need to make a Coke and a Smile (see "Rum Recipes"). *Photograph by Stephen Charles Nicholson.*

From left to right:
Guinea Pirate, from Cameron Martinsen; Have a Coke and a Smile; Guinea Pirate (see "Rum Recipes"); Rhum Agricole dates back to the early nineteenth century. *Photographs by Stephen Charles Nicholson.*

Above: Café Atchafalaya
features a cross between
Creole and classic American
South dishes. *Photograph by
Stephen Charles Nicholson.*

Right: The oldest rum distillery
in America. *Photograph by
Stephen Charles Nicholson.*

Left: Mixmaster James Rall at Tujague's. *Photograph by Stephen Charles Nicholson.*

Below: Only if you dare… another masterpiece from Dré Glass at Pearl Wine Company. *Photograph by Stephen Charles Nicholson.*

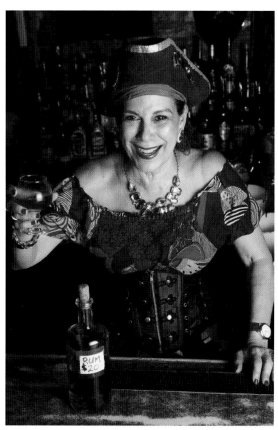

Left: Thais Solano, the lovely "piratess" at Pirate's Alley Café. *Photograph by Stephen Charles Nicholson.*

Below: Atchafalaya Restaurant Uptown. *Photograph by Stephen Charles Nicholson.*

Right: For centuries, cane syrup has been held up as a healthful alternative to refined sugar. *Eat cane syrup & molasses, save sugar by using best Louisiana molasses and sugar cane syrup / Luria-Fowler; Magill-Weinsheimer Co. Chicago. United States, 1918. Photograph. https://www.loc.gov/item/00653193/.*

Below: Pat O'Brien's getting a shipment of rum for its world-famous Hurricanes. *The Charles L. Franck Studio Collection at The Historic New Orleans Collection, acc. no. 1979.325.160.*

Leo Bruno, at the age of twenty-four, opened Bruno's College Inn, a favorite watering hole of students for decades to come.

Isadore "Izzy" Einstein, all five foot five, 225 pounds of him, made close to five thousand arrests around the country. With no background in law enforcement, he was the first to sign up for the Federal Prohibition Unit, what is today the Bureau of Alcohol, Tobacco and Firearms. He spoke four languages and was pretty good in four others. He enjoyed putting on disguises, finding illegal booze and making the arrests. He would waddle in, light up a cigar and gravely share with the victim his catchphrase: "There's sad news here."

Einstein used to brag he could find liquor within thirty minutes of getting off the train. In Chicago, it took twenty-one minutes; in Atlanta, it took seventeen; Detroit, eleven. Einstein got off the train in New Orleans at the Canal Street Station, got in a cab and asked where he could find a drink. The cabbie reached back a bag with a bottle of rum in it. In thirty-five seconds, he was intoning, "There's sad news here."

He marveled at New Orleans and how easy it was to get a drink. In other places, he had intricate sting-type operations and costumes to find the liquor. In the Crescent City, he would just go to a wedding and be handed champagne or would go to the docks where people openly sold beer.

Corruption, bad liquor and unintended negative consequences, as much as anything, brought the end to Prohibition. Many "Drys," citizens against alcohol, converted to "Wets" as they observed politicians pass anti-liquor laws and an hour later toast it with cocktails. Payoffs and kickbacks were rampant to enforcement officers.

Down in St. Bernard Parish, next door to New Orleans, rum-running was almost an honorable profession. A veritable colony of Isleños, families of Spanish Canary Island descent, have lived along the water for centuries. Their knowledge of the swampy area and the Spanish language and a disdain for the Eighteenth Amendment made it a perfect area for bringing in alcohol. They would bring in Cuban rum through the morass of swamp willows, mangroves, palmettos and oyster beds. To this day, cans of "molasses" containing once-illegal rum, lost bottles and even abandoned cases of spirits are still found in the mud.

Also, in New Orleans and St. Bernard Parish, an operation even lower than rum-running flourished—hijacking, a quaint exercise wherein one criminal steals the booty of another. It was piracy, twentieth-century style. Army deserter and general loser William Bailey and his partner Manuel Acosta sometimes brought liquor in themselves, but mostly they liked to

boost it from other bootleggers. They occupied the headlines for about four years. They would often identify contraband and pretend to be FBI and confiscate the stuff. Bailey was regarded as the leading figure in illegal booze operations, but his ending would not be as idyllic as Queen "Cleo" Lythgoe's, as we soon shall see.

The New Orleans–style of the law getting involved in all this saw the St. Bernard sheriff, two deputies, a chief and several officers getting arrested for a surreal record of graft associated with a rum ring they ran down there.

"If liquor is outlawed, only outlaws will have liquor," read many posts and signs of the day. There is no doubt the rise of organized crime was bankrolled by illegal liquor sales, and in New Orleans, it was no different. Sicilian Sylvestro "Silver Dollar Sam" Carolla operated in the Black Hand Gang here, and when its leader retired, he took over. His is generally considered the first modern Mafia operation in New Orleans. He went full force after the bootlegging industry.

Legend has it that Capone himself came down to test the New Orleans waters. Supposedly, he was met at the station by Silver Dollar Sam and his thugs. Local cops, working for Carolla, frisked the bodyguards, grabbed their weapons and busted up their fingers. Capone and his injured boys got on the next train back. There is also another local legend that Capone and his men were taken out into the snake- and alligator-filled bayous where they were threatened to be left, unless they went back home. Same ending to this version of the legend.

Carolla found it annoying that he had any competition. He "worked" with politicians, police, bar owners and gambling mavens to consolidate his control. If he ever got in trouble, an army of police "witnesses" would testify he was out of town. Remember the deserter William Bailey? He hijacked one load too many from Carolla and was greeted at his front door by Sam himself brandishing a sawed-off shotgun. With a shot to Bailey's chest, Silver Dollar Sam turned the New Orleans booze business into a monopoly.

The history of alcohol in the United States—and probably other places—includes passing off poison as legitimate liquor. This persisted into Prohibition, and many shady types seeing a financial opportunity in dealing would peddle some pretty nasty stuff. Hundreds of people died. In New Orleans alone, dozens died for their drink. Also, for those that chose the do-it-yourself route, processing any kind of alcohol requires safety measures that mom-and-pop enterprises would not always abide by. Similar to today's arguments for the legalization of marijuana, legalizing liquor, some reasoned, would make it safer.

The end of Prohibition was greeted with a fifteen-thousand-person parade down Canal Street with dozens of bands, circus animals and many plastered people. Parades are kind of a thing here. So are bars. Business was back in business. When World War II ended and the city experienced a new prosperity, our Mardi Gras mentality came back with a drunken fury. Bourbon Street began its remarkable reputation as ground zero for partying. Fittingly today, just a block off Bourbon Street is a bar named for the law that repealed Prohibition: the Twenty-First Amendment.

THE LARGEST FREE PARTY ON THE CONTINENT

Way down South they gave a jubilee
Them country folks they had a jamboree
They're drinkin' home-brew from a wooden cup
The folks dancin' got all shook up.
—Chuck Berry

Live like Nature's bastards, not her sons.
—John Milton, "Comus"

In a town where you can see drunk people at eight o'clock in the morning, it is no exaggeration to say we are a drinking ecosystem. From no open container laws, to bars that never close, to drive-through daiquiri stands, inebriation is so ingrained, the old tour guides joke that when you die of sclerosis of the liver here, the coroner puts "natural causes" on the certificate.

And nowhere in town is drinking more integral than during the celebration of Carnival. There cannot be a book about rum and New Orleans without mentioning Mardi Gras. Mardi Gras—like the Louisiana Purchase, like voodoo, like the Battle of New Orleans and like every other chapter of this book—is worthy of the attention innumerable books and articles have given it. Consider this a way-too-short look at a way-too-big party—sort of like one of the smaller walking parades lurching through an old New Orleans neighborhood surrounded by centuries of rum-soaked revelry.

A Mardi Gras Ball invitation. The Krewe of Twelfth Night Revellers still march on the first day of Carnival— January 6. *Courtesy of the Historic New Orleans Collection, acc. no. 1960.14.90.*

End-of-winter blowouts have been a feature of almost every European society back to the Greeks, who, in early spring, celebrated Dionysia for the god of wine. This was appropriated into Bacchanalia by the Romans. All throughout Europe, where winter sucks and spring is better, different peoples threw huge public festivals. Eventually, as Catholicism spread, these debaucheries evolved into more religious demonstrations. Mardi Gras became a specifically celebrated day on the church calender.

Let's get this straight first: The season is called Carnival, the day is called Mardi Gras. It's a locals thing. Carnival, from the Latin *carne vale* ("farewell to meat"), refers to how Middle Ages folks dealt with the Catholic tradition of Lent. Lent is the forty days before Easter where good Catholics go through a period of self-denial and introspection. The idea is that Jesus rose from the dead on Easter, thereby freeing us from the bonds of sin and death, and to honor such a great gift, we have to get ready.

Well, forty days is a long time to go without partying or eating meat or any of the other sacrifices folks made, especially when it is 1513 and Netflix has not been invented yet. Folks would blow it all out during the days before Lent: So long, meat! So long, sweets! So long, booze! See you on Easter. Farewell to meat. Farewell to the flesh.

Now, Easter Sunday is the first Sunday after the first full moon of spring. A little "pagan-y," but we will let that slide. Forty days before that (not counting Sundays) is Ash Wednesday, the first day of Lent. The day before Ash Wednesday is Fat Tuesday or, in French, Mardi Gras. It is the day to fatten up and get wasted before big bad Lent comes.

What our carousing Catholic commoners would do is dress as fantastical characters, cook rich foods and pound a bucketful of mead. They would grab a mule cart and put a fake king and queen on it. The royal couple would wave as they were pulled around the village, throwing their "riches"—wooden trinkets, shell "coins" or bags of flour—to the little people below. Meanwhile, the actual French royals would install new knights on Mardi Gras.

When Crescent City founders Bienville and Iberville came to the Gulf Coast, they named their first settlement on the Mississippi—about eighty miles from where New Orleans was going to be—Pointe du Mardi Gras. New Orleans's earliest story literally begins on Mardi Gras. Crazy huh?

Mardi Gras throughout the eighteenth and early nineteenth centuries was a little like Christmas in the sense that each family celebrated in its own way. There were no Bacardi shot girls giving away free rum to the public yet. It was acknowledged for the first time in government paperwork

as "Mardi Gras Carnival" in 1781. At that time, there were hundreds of carnival groups.

Now let's go to Mobile, Alabama. Seriously. One Mardi Gras night, a bunch of rich young gentlemen got trashed and broke into a hardware store, grabbing rakes, triangles, cowbells, anything they could bang and marched through the quiet streets of Mobile celebrating. They called themselves "The Cowbellions." Apparently one of them was a Mummer from Philadelphia, so there is that connection, but that is a whole other book.

Anyway, people loved it. The Cowbellions took it on the road. They came to New Orleans, where Mardi Gras was lavishly celebrated with balls and such, and the boys marched through the streets. New Orleans revelers were like, "Nice." In 1857, the Mobile boys and some New Orleans boys created Comus—New Orleans's first Mardi Gras parade.

Why Comus? Okay, let's go to back again to ancient Greece. Thomas Jefferson and many of the founding fathers were enamored with all things Greek. The Greeks, you see, invented democracy. And baklava. So, it was considered real patriotic, real American to adopt an ancient Greek ethos.

The most telling of this tradition is the explosion of Greek Revival architecture throughout the United States. Jefferson designed the Virginia State Capitol after a Greco-Roman temple. Washington, D.C., is a veritable Greek Revival handbook. And in French New Orleans, many of the rich rising American entrepreneurs wanted to flaunt their Amercanism by constructing large Greek Revival mansions. The Garden District, where the well-to-do Americans settled, still is predominantly a Greek Revival neighborhood, as is much of wealthy St. Charles Avenue. In the Creole French Quarter, a Greek Revival house meant the owner did not like his neighbors. By the beginning of the Civil War, there were more Greek Revival buildings in New Orleans than in ancient Athens.

Anyway, 1857 was smack in the middle of this Greekophilia, and these guys wanted to adopt a naughty-boy image. Comus is the cupbearer for Dionysius. In the poem "Comus" by John Milton, he kidnaps and terrorizes (and philosophizes with a LOT) a chaste young lady while wielding a cup and a scepter. The girl held out and was later saved. This was just the brand for a decadent Mardi Gras parade. In 1992, after refusing to racially desegregate their club, the oldest krewe, Comus, was not allowed to march anymore. Today, they simply have an annual ball.

Subsequent parades adopted Greek/Roman names over the years. These groups, very private and very white, called themselves "krewes," a more Greek spelling of the word "crew." In 1916, the first black parade

to incorporate took the name of a different sort of bad boy—Zulu. If you go to Zulu early on Mardi Gras morning, beg, borrow or trade a bottle of rum for one of their festive coconuts. These sit proudly on mantels across the country.

Today, there are over forty official krewes that roll parades on specific days and have proper balls. Bacchus is one of the biggest parades, featuring a giant papier mache dinosaur "Bacchus-saurus," where the public throws back the plastic beads they have hoarded trying to get them into its mouth. They also have a float with a swimming pool full of mermaids.

There are now krewe names that range from the Aegean, but even the newer ones maintain the theme; the all-women Muses is famous for throwing decorated high heels. Local kid Harry Connick Jr. helped start the parade Orpheus, the character associated with music, which features tons of bands. There are also parades out in the suburbs, across the state into Cajun country and yes, there is a Mardi Gras parade in Mobile.

Additionally, there are hundreds of unofficial krewes, micro-krewes, walking clubs and special gatherings, including traditional house parties, that also comprise the fabric of Carnival. These groups each have a unique personality.

The Society of St. Anne is known for its amazingly elaborate costumes; they wind from the back of town through the French Quarter. During the AIDS plague, the parade adopted a tradition of spreading lost loved ones' ashes, mixed with glitter, into the river. The ashes disappear but the glitter remains. As does the tradition.

On the other end of the respect spectrum is the wacky Krewe du Vieux (the words rhyme). It is comprised of a bunch of sub-krewes that adopt irreverent political, religious and sexual themes. Sometimes they are hilarious; sometimes they are gross. The esteemed journalist who wrote the introduction to this book, Chris Rose, was king of Krewe du Vieux in 2007.

And it goes on. Over a century old, the resplendent Mardi Gras Indians are groups of black revelers that were not allowed to parade back in the day and formed their own subculture. Members spend the entire year beading and feathering amazing Indian costumes. Look for the women's dancing groups like the Pussyfooters, Bearded Oysters and the Muff-alottas. There is a doggie parade named Barkus. There is a Star Wars krewe called Chewbacchus.

Carnival begins on January 6, Twelfth Night. Because Easter moves, Mardi Gras day moves—sometimes it is in early February, sometimes it is in March. A few times it has landed on Valentine's Day; imagine the costumes,

which range from romantic to kinky to bizarro. The Super Bowl came during Mardi Gras weekend in 2013, when San Francisco faced Baltimore. That was the game that the lights went out in the Superdome. Some say it was Vegas, some say Mardi Gras revelers forgot to pay the light bill.

And wait, there is more. Carnival is more than the parades, more than the clogged streets, more than the drinking. It is a phenomenon that is literally impossible to occur anywhere else in the country. Public drinking? Public nudity? Closing a city down on a Tuesday? Perching costumed drunks two stories up on a moving float and *throwing* things at the audience?

The two oldest krewes—Comus and Rex—hold their grand balls concurrently on Mardi Gras night in the same place with a giant curtain between them. Rex is the name of the krewe and the title of the king. Rex is the king of Mardi Gras. At exactly midnight, the curtain is drawn, the kings of Comus and Rex toast each other and Mardi Gras ends.

Police go through the streets of town and in the French Quarter announcing, "Mardi Gras is over. Go home." And the citywide cleaning begins. The next day, many devout New Orleanians arrive bleary-eyed to church to get the traditional ashes on their foreheads.

In reality, the cleaning of the city happens after every parade. Immediately after the last float rolls by, street sweepers, dump trucks, plows and gangs of prison trustees sweep, hose and collect the ankle-deep debris from the street. The streets are never as clean as they are right after a parade. Above hang the beads that got stuck in the live oak trees, where they create a shiny colorful tunnel until next Mardi Gras, or until a hurricane blows them down.

Then all the broken beads, beer cans, Popeye's chicken boxes, rum bottles, busted Styrofoam coolers and the occasional cell phone or wedding ring are taken away. And weighed. They weigh the garbage and total it up. Around Friday after Mardi Gras is done, there is a squib in the paper: "Last year we collected 14.3 tons of garbage, this year it was 14.6. It was a good Carnival!"

BOURBON STREET AND MARDI GRAS MENTALITY

You can't drink all day if you don't start in the morning
New Orleans is a lady,
and you really oughta know to come when you hear a lady call
Relax just a minute honey in New Orleans, the biggest whore of all
—Song by Stuart Baker Bergen,
performed by New Orleans legend Becky Allen

Bourbon Street stinks. And not just in the olfactory sense. The clubs cater to the frat boy crowd, and the street itself is rife with gutterpunks, grifters and wackos, all surrounding the poor clueless Midwestern family thinking this is what New Orleans is.

But it was not always this way. After World War II, with a newfound economic growth in the city, new neighborhoods grew toward the outskirts and new suburbs were created. The French Quarter started to become a quaint neighborhood to visit. Many of the old-line bars and restaurants began to acquire a "classic" feel. Visitors and locals would spend a Friday evening at Pat O'Brien's or the newly opened Preservation Hall. Interestingly, both of these places are not on Bourbon Street, they are just off the famous road.

Rue Bourbon was a residential street, complete with the famous Desire Streetcar running down the middle until the 1940s. Its name does not come from the whiskey, but from the French royal family. When Pauger, the city's designer, laid out the streets in the 1720s, he named Bourbon after the royal's family name. In fact, bourbon whisky got its name from Bourbon County, Kentucky, which also got its name from the French royal family.

Bourbon Street. *By Nick Solari [CC BY-SA 2.0 (http://creativecommons.org/licenses/by-sa/2.0)], via Wikimedia Commons.*

As the aforementioned gentrification of Gentilly and metropolizing of Metairie away from the center of town happened, nightclubs and burlesque joints started opening along Bourbon Street. These places were among the first in the country to offer air-conditioning, beer taps and even televisions. They were urbane environments; the strippers were teasing more than sleazing and a gentleman would put on a jacket and tie and bring his wife (or a secret substitute) and sip two-dollar rum punches at a table before the stage.

Madame Francine's, at 440 Bourbon Street, was a popular naughty spot in the late 1950s. It might have been the first place to put up posters of scantily clad ladies. There was a 1950s New Orleans–based Western television show called *Yancey Derringer* that featured a gambling hall with the same name—Madame Francine's. Tourist fans of the show would seek out the place, and it is fun to wonder what they thought when they innocently strolled into a strip joint. Today, it is known as Fat Catz Music Club, the only nudity now occurring among the patrons on particularly wild Carnival nights.

At that time, the Sho Bar, at 220 Bourbon Street, was the home of Kitty West, "Evangeline the Oyster Girl," who would emerge from a giant oyster shell and fetishize an enormous pearl. There was another young woman, Fannie Belle Fleming, also known as Blaze Starr, who stripped nightly. Her biggest fan was the governor of Louisiana, Earl Long, brother of Huey P. Long.

Earl would skip work in Baton Rouge to see his sweetie Blaze. They engaged in a semi-public affair, which made her famous and did not affect his electability in the least. Eventually, Blaze became a sort of first lady (although there actually *was* a first lady already), sometimes dining with the state's nobility at the Governor's Mansion. Earl eventually was committed to a mental institution, while Blaze went on to milk the affair to make her a modest burlesque star. She also wrote a memoir of the affair and eventually cashed in when it was bought to create the film *Blaze*, starring Paul Newman and Lolita Davidovich, in 1989.

The third Playboy club (after Chicago and Miami) opened right off Bourbon Street in 1961. Local musical favorites Al Belletto and Ellis Marsalis (father of Wynton and Branford) would play nightly. Sammy Davis Jr. would stop by. Today, weirdly, it is the site of Playboy's longtime rival, Penthouse Club.

By the end of the 1960s, Louis Prima, the Meters, Danny Barker, Al Hirt, Dr. John and a myriad of other musical legends had done stints on Bourbon Street. The city turned Bourbon Street into a walking (or staggering) mall in the 1970s, and things really got ratcheted up. With the Super Bowl being here ten times, the NCAA Final Four five times and Jazz Fest and Mardi Gras every year and with the city being one of the top convention destinations in the country, there is a seeming constant horde of thirsty guests to crowd the nine blocks of depravity. Local drivers know not to try to cross Bourbon Street on a Saturday night as an endless train of inebriated people carelessly lurch in front of cars.

The classic Galatoire's Restaurant, opened in 1905, and the charmingly seedy Clover Grill, established in 1939, reside on Bourbon Street, acting as historic and demographic boundaries: Galatoire's is a classic Creole restaurant that serves, along with its classic menu, the Sportsman's Paradise. Named after the state's nickname, it is a fruity rum drink, and proceeds from its sales go to support sportfishing in Louisiana. Look for the ingredients in the "Rum Recipes" section of this book. Galatoire's is usually packed on Friday afternoons with lawyers and others getting a head start on the weekend.

The places get progressively more decadent as one walks downriver from Canal Street. Hotels, music clubs, strip clubs, gay bars and daiquiri bars get brasher and brasher until reaching the Clover Grill, where cooks will fry up your burger under a Cadillac hubcap. A bit farther down is aforementioned Lafitte's Blacksmith Shop, the last bar on Bourbon Street. But keep walking! In a few more blocks is Frenchmen Street, the place where locals actually go to hear music these days.

It is not all bad news, however. There are many reasons to brave the odoriferous walk along Bourbon Street. The excellent Bourbon House

restaurant offers a twist on a Dark 'n' Stormy using the Black Duck Bar's Papa Pilar 24 barreled rum, which is so much fun to say. Another bright spot, with live music nightly, is Fritzel's. It offers a Hurricane that has five (five!) shots of rum, two or three more than other spots.

Though Bourbon Street is the apotheosis of the id (release every inhibition), the attitude seeps into other neighborhoods and into the mindset of locals and visitors alike. There are as many rum daiquiri stands as there are Walgreens. This local zeitgeist spills out beyond binge drinking and breast-flashing, too. The food is incredibly rich here for such an oppressively hot and muggy place. Deep-fried oyster po'boys with Crystal hot sauce (Crystal, not Tabasco, seems to be the choice of locals); heavy, hearty seafood gumbo; savory jambalaya; saucy shrimp étouffée and hot oil-fried beignets are just a taste of the belt-tightening food here.

Because of hurricanes, not a lot of big companies want to invest billion-dollar facilities here. There is presently one Fortune 500 company in town, a financial firm. The state is constantly strapped with its limited financial options. Education is a challenge; Louisiana is one of the most illiterate states in the country. There are not a lot of healthy reasons to be here. The point is, people that are here *want* to be here.

It certainly appeals to the creative types. There is an artistic stripe in the community—jazz and blues artists, culinary geniuses and Mardi Gras Indian costumers, to name a few. William Faulkner wrote his first pieces here, including *New Orleans Sketches*. Tennessee Williams drank more than his share of rum here. Everyone from Mark Twain to John Goodman loves it here. So there emerges an artistic view of life. And there seems to be a "for tomorrow we may die" attitude from decades of mortal calamities: the Battle of New Orleans, Union occupation, economic collapse, floodings and Katrina.

All this imposes a "drink now, pay later" vibe. What could be called our Mardi Gras mentality is hard to escape. From the French colonists' lust for tafia to today's ubiquitous Styrofoam daiquiri cups, New Orleans harbors a daring, what the heck lifestyle. As far back as 1828, United States congressmen debated a tariff on the Crescent City because they saw potential profit on the drinking culture of the city: "A ship owner, for example, sends his ship into New Orleans and takes in a cargo of Western produce. He ships it to Barbados for rum or molasses, [then to New England to make more rum]…the value of the original cargo laid in at New Orleans is now doubled. Now he and his crew can afford to drink rum through their own freight."

Sure sounds like envy.

VOODOO—THE SECRET POWER, THE LITTLE-KNOWN GLORY

The English must bring guns.
The Portuguese must bring powder.
The Spaniards must bring the small stones, which give fire to our fire-sticks.
The Americans must bring the rum made by our kinsmen who are there,
for these will permit us to smell their presence
—Dahomian chant to long lost relatives in America

I want to save you from humiliation because this is full of cow poo.
—African Diasporic Religion practitioner, expert and friend.
This was his comment on this chapter.

Of the many, many facets of New Orleans culture that are barely known, let alone understood, the presence of voodoo may be the most publicly misconceived. It is exceedingly difficult to lay out exactly what voodoo is because there are innumerable varieties and practices. Even practitioners attempt to "correct" other versions in their narratives, so any research yields conflicting information. And for any outsider to come along to explain things, that person gets lots of free lessons on where he or she went wrong. There is little doubt this particular chapter will garner the most comment of any in the book. It is entirely possible every single sentence will have a challenger.

Besides documented research, many experts were consulted for this overview—voodoo leaders in New Orleans and experts practicing other African-based religions in Brazil, Mexico and Ghana as well.

And they all felt the other ones got it wrong, which is fine because voodoo may be one of the least restrictive religions in terms of its canon and practice; many people will see it in their own way. The very rituals and habits always get a "personal touch" from the faithful, so there are no set protcols like in a Catholic Mass. There are many reasons this much-maligned, incredibly beautiful practice is seen the way it is, but first let us try to pin down (no pun intended…well, okay, sort of) what voodoo (or vudu) is.

It starts in West Africa, although arguments even exist about where. Some say Benin; the voodoo pope is in Benin. (Voodoo has a pope? Who knew?) Some say Nigeria. Others point to various lands from the Bight of Benin to Senegal. Additionally, Brazilian-based religions source their faith from where their slaves came from: Angola and even Mozambique in the East.

Before white folks arrived in Africa, there existed many strains of monotheistic or polytheistic religions—it was important to Europeans to pigeonhole a fluid concept into one hole or another. Some folks persist in this dualistic thinking. These were nature-worshipping religions. They utilized something akin to saints, called orishas, which are kind of like deities and also kind of like the actual natural thing itself, like mountains and the ocean.

When Catholic missionaries arrived, they were content to accept African modifications to spread the Word. It was a funny synthesis because the tribes thought, "Well, the white men believe in one God, but they have all these other spirits like St. Peter, who is clearly the orisha gatekeeper Papa Legba (or not, there are many interpretations), and Yemaya is the white man's Virgin Mary" and other harmonies. And since they did not have wine, they could use rum! So, while they were adapting Catholicism to their own beliefs, it seemed to mollify these intrusive priests. Africans were more or less fine with Catholicism, and the priests thought they were converting these guys from demon worship.

These folks did not build churches or have elaborately detailed texts. Instead, ceremonies existed for healing, blessing, gratitude, supplication or others purposes. The proper orishas were approached, and each had his or her favorite offerings and fetishes. They danced, they prayed and they drank rum.

When slaves were abducted from these countries, they kept their faith in their hearts and secretly practiced whatever rituals they could. Depending on what country they were taken to, their faith evolved into what could clumsily be called orisha-based religions, or better, Post-African Diasporic Religions. Voodoo is one strain; there are many other inflections. But this list is far from complete; in fact, it is not even close. Cuba has Santeria and

Palo; Jamaica is the center of Obeah; Brazil has Macumba, Candomblé, Santo Daime and Umbanda; Trinidad and Tobago has Trinidad Orisha; the American South has Hoodoo (which is NOT the same as Voodoo) and of course, Haiti has *voodou*.

In Haiti, orishas are called "Lwa," or "Loa." (Or they are not. There are numerous articles online about how "Orishas are NOT Lwa!" See what I mean? There are always contradictions.)

In 1791, Haiti blew up. Toussaint L'Ouverture led an uprising of poor folks against rich folks, and the rich folks lost. Suddenly, thousands of French-speaking, Catholic, voodoo-practicing refugees arrived in Catholic/French New Orleans. In the days of slavery, many Haitians lived in the old city, or just outside, with their own black servants, their own barrels of rum and papers that declared them to be *Gen de Couleur Libre*, or "Free Man of Color."

These immigrants spoke Creole, the Haitian version of French. So, as the white aristocrats called themselves Creoles to show they had European lineage, the word soon applied to certain people of color as well. Today, there are rich ladies from old families uptown announcing, "You know, my family is a Creole family." And there are funky dudes on Frenchmen Street that will brag, "I play Creole music." And of course, we have Creole tomatoes (a whole other book). It is quite confusing to pluralistic types. In New Orleans, Creole means "New Orleans-ish." If you open a "Creole restaurant" in Milwaukee, ya mama bettah be from New Orleans dawl.

These Haitians would gather publicly for their social events from time to time. People could come to see exotic displays and experience a different sort of French-ness there. The place they gathered is today the very site of Pat O'Briens, a party spot for over two centuries. These gatherings soon moved to Congo Square, just outside the French Quarter.

New Orleans Creoles (the white ones) had the so-called Code Noir, the Black Code, an actual list of dos and don'ts for the interaction of light people and dark people. This code basically said the following: Everyone has to be Catholic; Jews have to go, as in banned from Louisiana (like Prohibition, prostitution, and other attempts at local lifestyle modification, this rule was largely ignored), no interracial marriage (this got changed by that Spanish governor they threw out a few chapters ago, another reason they hated him) and about fifty other mandates.

A couple of interesting tidbits in the code had ramifications vibrating to this day. First, slaves got Sunday afternoons off. Presumably this was so they could go to church. The other loophole dictated that blacks could not gather in the city limits, but they were fine to be just outside the city.

In today's Louis Armstrong Park, which is across the street from the French Quarter, in those days outside the city, folks would gather on Sundays. There, in Congo Square, they would sing, dance, trade and sell baskets and candy and things. Rum was surely imbibed. A whole culture was evolving and guess what? Many of the dances and songs were voodoo rituals, celebrated right under the noses of the whites.

The reason these weekly festivals resonate today is the music that evolved out of these different peoples mixing in music and reverie coalesced into the very cradle of jazz. Africans from diverse tribes mixing African music traits like polyrhythms and syncopation with the white, Mozart-type music they were hearing is not a bad description of early jazz.

New Orleans voodoo today is recognized as a proper voodoo faith in its own right. There was a silly article in a national magazine that recently declared "there are approximately 350 to 400 active practitioners" in New Orleans today. Man, there are at least twice that many every year in an annual voodoo drum festival in the French Quarter. It is not easy to give a hard number of the faithful because there is no registry or openly public church. Some folks do all-out ceremonies in their homes or in cemeteries or parks every week or month. Others use voodoo when they need something like a new job or a new husband and they go to a mambo, a priestess, or to a houngan, a priest, for a spell. Some folks simply carry a gris-gris, or talisman, in their pockets.

The most famous mambo, without a doubt, is the provocative Marie Laveau. She lived in New Orleans in the mid-nineteenth century, and a pretty good synopsis of her biography is "I don't know, I don't know, and neither does anyone else." There are some extant facts and many persistent legends, but there is precious little hard evidence on her life. Because she was a woman, there are narratives that pull the story one way. Because she was a person of color, there is a tug in another direction. Because she was both a woman and of color, there is yet another competing narrative. Because she is the hero of a marginalized religion, many other stories emerge that tell more about the desires of the storyteller than of poor Marie Laveau herself.

It seems Laveau, a light-skinned woman of color, was a hairdresser and had entrée into both white and black homes. She knew all the town gossip and apparently could leverage this gossip for personal favor among important people. It is said she had a daughter that looked just like her, and they would often dress the same, so folks would believe she was teleporting.

She prayed in St. Louis Cathedral every Sunday and conducted voodoo rituals with her pet snake Zombi under a full moon at the lakefront. One

story has two thousand people, white and black, attending. Many people believe Laveau led the crusade to banish public execution in the city, and many stories of the time relate how she cured people with her gris-gris.

It is not even certain she is actually buried in the tomb that bears her name. Though it is likely she is interred in historic St. Louis Cemetery No. 1 in an elegant Greek Revival tomb, other voodoo followers have claimed to have proved she is in at least two other tombs in the same cemetery. The tradition is to invoke Laveau to help in some way, and when the help arrives, the petitioner leaves hairpins (kind of like a saint symbol), bottles of rum (always empty these days) and then draws an XXX on the tomb.

Today, a much stricter cemetery staff removes the offerings and the Xs from the official tomb. It is an ongoing job, as the other two tombs—the so-called faux Laveau—are also covered in memorials and Xs. And Marie Laveau has become almost a saint to some in New Orleans voodoo.

One of the most unfortunate things to happen to Marie Laveau's image was her national obituary. Locally, she was extolled as a saint and was recognized for her life of self-abnegation. Nationally, though, many papers referred to her as "beautiful," "benevolent" and "wonderful," and almost all the stories are made-up facts and refer to her as the voodoo queen in dark and insinuating ways. The *New York Times* reported she was ninety-eight years old; her tomb reads sixty-two.

The worst however was her obituary in *Harper's Weekly*, which had a history of "exoticizing and demonizing practitioners of Voodoo." In a totally bogus obituary, festooned with dripping Spanish moss, dark tombs with phantoms swirling and creepy skulls, she is basically relegated to the position of misguided demagogue. About a century later, a pop song called "Marie Laveau" was written containing the following lyrics:

> *She lives in a swamp in a hollow log*
> *With a one-eyed snake and a three-legged dog*
> *She's got a bent, bony body and stringy hair*

Her treatment is instructive in how voodoo still gets a bad rap in many circles. Since not much is known to outsiders and there are vague rumors of curses and hexes, people make stuff up. Popular films such as *Live and Let Die* and *The Serpent and the Rainbow* are cartoon characterizations of the faith, for example.

In the New Orleans–shot film *Runaway Jury*, John Cusack goes into a voodoo shop with hanging herbs and snakes and skulls and approaches the

shopkeeper, played by beloved New Orleans actor Adella Gautier ("Adella Adella The Story Teller"). Now Gautier is a lovely woman of color, and she is shot even darker in the movie. Cusack approaches her in English and his supposed local expert friend chides him to the effect of, "Oh she don't speak English, she's a Cajun, they only speak French." Quoi?! Cajuns are descendants of French exiles from East Canada, and really Catholic. The non–New Orleans producers had no idea; they just wanted French, black, mysterious: "Y'know real Voodoo stuff!" They even made poor Adella's last name look more French by unnecessarily adding an "H"; she was "Gauthier" in the credits. Ah, c'est la vie.

Moreover, voodoo appears in hyper-Catholic countries, where anything not in line with the Canon is sinful, demonic and evil. Voodoo is not organized with highly publicized officials holding forth on ethical and political issues. And though there might be some voodoo followers who have their views, who would put that on CNN or Fox?

Voodoo is not celebrated in large expensive houses of worship with opulent decorations and silver and gold sacred tools. Voodoo evolved as a poor person's—actually worse than poor, an enslaved person's—faith. To this day, voodoo takes place in humble places; there are carvings instead of stained glass, cigars smoked instead of extravagant censers, and cheap rum sipped from a bottle instead of wine in a gold chalice.

In slave days, outside of New Orleans, voodoo was strictly proscribed with harsh punishments. Voodoo was literally viewed as evil and dangerous. A slave could be tortured as a witch if discovered. One of the stories of the infamous voodoo doll is that enslaved mothers would make dolls of the orishas, or lwas, for their rituals and then claim to the master that they were simply dolls for the kids.

Voodoo believers say they communicate with the dead to facilitate the actions they desire in their lives. Despite the fact that most religions have official relationships with the dead, such as Christians praying souls out of purgatory or wali, Islamic saints, who can work miracles or in many religions the veneration of holy human remains to appeal to that person's spirit and myriad other beliefs, many outsiders view voodoo as some sort of necromancy.

It must be noted, however, that New Orleans's commercialism hurts voodoo's image as well. There are so many cheesy voodoo shops with their tacky, plastic gewgaws and celebrity voodoo dolls and wacky folks on the street passing themselves off as actual voodoo wizards that it creates an irreverence for something that in any other case would be honored. This

shambolic presence alone cheapens the image of voodoo. According to Tony Kail's article "Invoking Spirits: Hoodoo, Voodoo & African Religions in the Alcohol" on medium.com: "The word [Voodoo] has been appropriated as a label for sports teams, concerts, chicken wings and doughnuts. It is interesting to note that we don't see as much use of other forms of world spirituality used quite like we do with Voodoo. There is no Buddhist economics. No Christian dipping sauce and I've yet to find a sports team named after Islam."

There are a bunch of legitimate voodoo shops in New Orleans today, and it would be profitable for any interested visitors to ask around first. If the place is really garish and has a sign that reads, "Please no photos," it is probably baloney. A list of legitimate places appears in the Notes section of this book.

Voodoo is an intensely interesting, confusing and lovely subject to explore. Consider this discussion a thumbnail. Bourbon Street with its rum literally running in the streets appears in the last chapter as a popular, positive place that has its dark side, and voodoo, the faith that has a dark reputation, is in reality a comfort to millions of people. The two become a sort of yin-yang of the city. And this chapter cleanses some of the bad news from the previous ones.

Plus, it cannot be overlooked: Voodoo has raised rum drinking to a spiritual exercise.

RUM IN THE CRESCENT CITY TODAY

Dwèt pa ka bwè tafia, i ka montré ki koté yo ka vann li.
A finger does not drink tafia, it shows you where it is sold.
—*Creole adage*

We have the happiest yeast alive.
They are understood and pampered.
—*James Michalopoulos, rum maker*

By the end of the twentieth century, no one was making rum in the continental United States. In 1995, a soon-to-be-well-known artist imported a French perfume still and wanted to try his talented hand at rum making. But before getting to him, it's instructive to remember what the American hooch horizon was like at that time.

Bar shelves were much lighter in the 1980s than they are today. Americans who wanted wine could choose between red (Burgundy) and white (Chablis). Chablis was not even Chablis. It was a generic term for California white wine. Our premium brews were beer-flavored soda. And though there were some choices, it seemed like there was one brand for each liquor—Smirnoff vodka, Jack Daniels bourbon (not technically a bourbon), Jose Cuervo tequila and Bacardi rum.

Then there came a sort of culinary enlightenment. It began with food. Through the 1950s, 1960s and 1970s, there was not a very broad menu—pizza or Chinese was about as daring as Americans got. Of course, specific

Celebration Distillation, the oldest rum distillery in America. *Author's photograph.*

ethnic groups had their native diets, but it was not until the 1980s and 1990s that the mainstream started to partake. We discovered wonderful things like sushi and hummus, yogurt and kiwi. Moms would bring home avocados. Downtown, between the diner and the pizza place, an Indian restaurant opened.

This desire for more adventurous things on the table spilled over into people broadening their drinking palate as well. For example, at the supermarket, the two choices of wine became dozens: Californian, Australian or Chilean and the old guard European vineyards saw a rise in demand for different wine varietals. Local breweries started popping up, producing more than light lagers and introducing us to beers like IPA, Brown Nut Ale and Hefeweizen. It was inevitable this drive to experiment would get to rum.

It was during this burgeoning taste environment that James Michalopoulos returned from France with that cute little still. He had friends in Europe making their own spirits. He was going to fiddle around with the still to create a New Orleans–based liquor.

The son of a well-known Pittsburgh architect, Michalopoulos came to New Orleans and would ride his Vespa around with easel and paints bungeed to it. He would stop and capture a rickety house, or an aging car, or the way the light diffuses out of a lamp on a humid night along the Mississippi. Every now and then, he would sell a painting. Soon, he came to be the visual spokesman for the city.

Art aficionados around the world know the paintings and sculptures of Michalopoulos. Visitors to New Orleans will see his prints on the walls of a stunning amount of restaurants, bars and living rooms. His vision of melting, candy-colored houses; rangy, flowing car grills and verdant, vibrant landscapes actually defines how New Orleans looks to many people. No one has created more Jazz and Heritage Festival posters than he. His portraits of Fats Domino, Allen Toussaint, Dr. John and others stand as bold iconography with a funky New Orleans accent.

He has also painted the coolest picture of a giraffe ever.

Michalopoulo got some chemists, artists and alternative thinkers together and decided to design a liquor. They chose rum because sugarcane grows all over the place in Bayou Country. They tried, did not like what they got, and tried again and again. They were a troupe possessed. By the time the millennium arrived, they dubbed their distillery Celebration Distillation. They were producing Old New Orleans Rum, and soon they were expanding. Rather than buying fancy new equipment, Michalopoulos stuck to his "Stay Local" mantra and had in-house engineers convert dairy tanks into pot stills.

"I enjoy the challenge of working out the dynamics of the fermentation process," Michalopoulos admits. "We have mastered the conditions required to produce a superb stress-free life [for our yeast]. The smooth delicacy of our rum is in part a testament to the mastery of fermentation science."

His, and his staff's, preoccupation with the contentment of their yeast gives an insight into why artisanal products, like their rum, appeal to today's consumer. Like buying an original painting instead of an assembly line print, folks today can sense the pride and joy in the product. Though he is an artist by trade, Michalopoulos illustrates how quality rum making is a mix of art and science. "I had an early exposure to distillation," he relates. "For a science project in the seventh grade I cobbled together a water distillation unit. This exposed me to the concept of chemical separation. The distiller's grasp of the subtleties of this process enable the production of unique and superior products. The variations in technique are endless."

In 2005, around the time of the distillery's tenth birthday, Hurricane Katrina filled their factory with twelve feet of water. They still show you the waterline, far above your head, on the rum tour. Celebration could not produce for a while, but much of the extant product was saved. After the storm, there was an appreciation of all things New Orleans, both nationally and locally. Old New Orleans Rum was starting to appear in many more local bars. The company invested in a sugar grower in a nearby parish so it could guarantee a consistent quality molasses and support local business.

In the beginning, the mash was fermented in a process known as open air fermentation, which allows the environment to affect the flavor. But today, as they have created a distinctive flavor profile, Old New Orleans Rum ferments in giant, closed, tightly controlled vats, with their spoiled little yeasts. The temp and controls are overseen by the "Lady Fermentor." (Spelling note: The vats are fermenTERS, and the controller is a fermenTOR.)

Ain't nuthin' more New Orleans—spices for spiced rum. *Photograph by Stephen Charles Nicholson.*

Two copper pot stills produce the final product. The company's in-house chemist and distillers agree that pot stills create a richer flavor than column stills. The first baby to be born is called Old New Orleans Crystal, a clear, crisp rum perfect for mixing.

A portion of the Old New Orleans Crystal is then aged in barrels that formerly housed Kentucky bourbons and fine sherries for at least three years, producing the company's amber, a rich golden rum that inhabits almost every bar shelf in the city.

The final member of the Celebration Distillation triumvirate is a concoction of organic spices, some secret, others exotic—Madagascar vanilla and locally produced cayenne to name two—which create Cajun Spice. This goes well in almost any mixer, even iced tea, and desserts such as bananas Foster and Drunken Apples. Those recipes appear in the "Rum Recipes" chapter of this book.

Recently, Celebration Distillation, celebrating its twentieth year, married some pre- and post-Katrina product and created a twenty-year-old blend called King Creole. Think single-malt scotch as you get hints of vanilla, burnt orange and spice. Its finish is dry, with a whisper of caramel. In 2016, the Beverage Testing Institute, a marketing service company that provides alcohol ratings and runs the site Tastings.com, came back with an astronomical rating of 96 for King Creole with the certification of Superlative, meaning the oldest rum maker in the land had crafted the highest-rated rum in the land.

Yet another delight invented by the James Michalopoulos gang is a fizzy lifting drink called Gingeroo. Organic, crushed ginger infused into their own rum and a touch of cayenne to make chilly-low-alcohol-perfect-for-muggy-New Orleans joy. It comes in heavy bottles with a ceramic clasping flip top; many hip New Orleanians keep them for infusing olive oil, watering herb gardens and other hip things.

In the past few years, more players have arrived on the New Orleans "rumscape," giving the Crescent City even more sweet options.

Early one morning in 2011, Trey and Tim Litel and Skip Cotese were sitting in a duck blind, a common activity in south Louisiana. The swamp they were in was surrounded by sugarcane fields. They were chatting about life down here, with the amazing food and the biggest party in the country every year. The gist of their talk was "why don't we make a rum as decadent as the lifestyle?"

Today, in the rural town of Lacassine, sits Louisiana Spirits Distillery, literally in the middle of a cane field. It produces Bayou Rum, an all-local-

Left: Magic in a bottle—ginger, cayenne and rum. *Right*: Bayou Rum from the heart of sugar country. *Author's photographs.*

ingredient concoction with a growing reputation. The company sources its cane from M.A. Patout & Son sugar growers out of Patoutville, which is not only cool that it is local, but how much fun is saying, "Patoutville?"

Its clear rum, Bayou Silver, makes a great choice for daiquiris and mojitos. Bayou Spiced has a fine sweet edge that will complete your rum and Coke. The folks over at Louisiana Spirits Distillery claim their top-of-the line Bayou Select has a "sensuous finish." That alone should attract some curiosity.

The funnest offering from Louisiana Spirits Distillery is its satsuma. A satsuma is a wonderfully sweet, easy-to-peel swampland orange. The company infuses the satsuma juice into its rum, creating something that verges on a liqueur and also refreshes.

Our next rum maker has chosen a Gothic route toward rum. It is well known that wolf-headed humans wander the swamps and bayous around New Orleans and will bite your face off if you are not careful. Well, it is well known to Cajun children anyway, and this mythical creature is modeled on the old French *loup-garou*, a werewolf, only repronounced to rugarou, rougarou or rugaru, etc.

Rougaroux Rum from Donner Peltier Distillers. *Author's photograph.*

Out in Thibodaux, a lovely town boasting many Cajuns, the Donner-Peltier Distillers populate local taverns with Rougaroux (yep, another spelling) Rum. In the 75-year-old, family-owned mill, they started making rum in 2012. The company's clear rum is called Sugarshine, its aged rum has the spooky name of Full Moon Dark and the intriguing name 13 Pennies Praline Spiced rum is flavored with vanilla and locally produced toasted pecans. Why 13 Pennies? Well any Cajun kid will tell you, you have to put 13 pennies on your backdoor stoop to keep the rougarou away.

Back in New Orleans, there are more and more brand-new makers, many of them using former Celebration Distillation distillers. Seven Three Distilling gets its name from the number of neighborhoods in New Orleans, and it plans to produce a spirit for each one. Not sure which one will get rum, but it is hoped they do either Black Pearl Rum or Desire Rum because it would just sound cool. Lula Restaurant Distillery will be, well, a restaurant, bar and distillery producing, among other products, rum. Roulaison Distilling wants to produce a rum "that doesn't taste like any other rum." *Roulaison* is the Creole word for sugar harvest. Unlike during the Civil War and a few other rare moments in the Crescent City's drinking history, we shall not lack for rum.

Most of these companies offer tours of the distilleries. Heck, most get rented out as venues. At Old New Orleans, the company sends out a funky bus to pick up guests in the French Quarter a few times a day. To get to Bayou or Rougaroux, it would be best to pair a visit with a plantation tour at one of Louisiana's many historic sites, as they are a bit out of town. Their contact information appears in the "One for the Road" section of this book.

POSTSCRIPT

Two days before the Battle of New Orleans, one of Andrew Jackson's officers captured three pesky British supply boats out in the swamps. They were laden with "rum and biscuits." Jackson was grateful for the hit, but he was more appreciative to give his valiant boys who had been out on the line over a month in the sloppy, chilly fog, and without rum, a little nip. Then they saved the city. The lesson here is go drink your rum y'all, then defend New Orleans!

Barrels of soon-to-be awesomeness.
Photograph by Stephen Charles Nicholson.

RUM RECIPES

Pour four ounces of rum into a glass. Mix your egg yolks, cream, vanilla and nutmeg in a bowl. Throw that mess out of the window and drink the rum.
—The proper way to make eggnog

The beauty of rum is that it mixes well with stuff we want to drink anyway—soft drinks, juices, creamy things. Generally, the idea is to use clear rums for overpowering flavors like punches and aged or spiced rums where a rum flavor is desired. Of course, the higher-end rums can be sipped neat or on ice like scotch and other fine spirits. Finally, as a lagniappe—that is New Orleans talk for "a little something extra"—a recipe for New Orleans's classic bananas Foster is included.

If you want to act like an actual bartender when mixing, remember to add rum to non-carbonated liquids, but fizzy stuff goes in after the rum as the bubbles will mix the cocktail for you.

These days, almost every bar worth its shaker has a master or two that has a unique rum cocktail. This section is woefully inadequate. A whole book could be done just on the countless concoctions of rum drinks here. Syrups and bitters made in-house, exotic ingredients and imaginative presentations make this list only a sip of what New Orleans watering holes offer. Herewithin are some recipes, starting with the classics and finishing with a sample of some of the new superstars of New Orleans mixology.

Rum and Cola

No doubt to the joy of the major beverage company, most people call it a "Rum and Coke," to the point "Rum and Cola" does not even sound right. With this simple drink, keep the ratio of mixer to rum 2:1; however, some tastes may prefer a milder 3:1.

4 oz cola
2 oz clear, aged or spiced rum
Rocks glass, over ice

In fairness to Coca-Cola's major rival, a fun alternative is to find Pepsi Crystal, a colorless cola, and mix it with white rum. Then serve it clear to confuse your friends. For more fun, color the clear drink with different food colors to make a splashy party presentation.

Cuba Libre

Same as above, add a squirt of lime and garnish with a lime. In certain parts of Miami, this drink, which means "Free Cuba," is sometimes called La Mentira ("The Lie").

Mojito

A drink with mysterious origins, the stories of its beginnings are as muddled as the mint used to make it. People cannot even agree on what the name means.

5 or 6 sprigs of fresh mint, save the prettiest one for garnish
Crushed ice
1 oz simple syrup

2 oz clear rum
Quarter lime chunk
Splash of club soda

In a rocks glass, moosh up the mint leaves with the back of a wooden spoon. (Or, if you're adventurous, pull out that muddler you got as a Father's/Mother's Day present and never used.) Add the ice, the simple syrup and rum. Squeeze in the lime squirt. Swirl it around to make everything cold. Add the soda. Decorate with the lime wedge and a mint sprig. If you use Old New Orleans Crystal Rum, you then have a NOjito. (Sorry, could not resist).

Sweet(er) Tea

By Old New Orleans Rum
Old New Orleans brought out a neat inversion of the Southern classic, sweet tea, which is interesting because New Orleans is not really a sweet tea town. But with this drink, it may convert.

6 oz unsweetened iced tea
2 oz Old New Orleans Cajun Spiced Rum
Garnish with lemon chunk and mint sprig

Grog

British vice admiral Edward Vernon wore a grogram coat, so he got the moniker "Old Grog." It is an English pronunciation of the French gros grain or "thick weave." Anyway, the old sailor wanted to reduce drunkenness amongst the crews and ordered water and lime juice mixed into their daily rum rations. The lime offset the nasty

water taste, and it also started to prevent scurvy, which was a bonus. The resulting drink became the basis for many incarnations named for "Old Grog" himself.

1 oz dark rum
3 oz water
¼ lime chunk, squeezed
Serve over ice

Or on cold nights at sea, when tea will not cut it, substitute hot water. There are many variations since the first one was forced on British sailors in 1740.

(An Actual) Daiquiri

How the Styrofoam cup version of this beverage ended up being called "daiquiri" is a case of pop culture crashing into culture culture. The original daiquiri got its name from a Cuban beach, which today seems to be a Club Med or something. It first appeared in New York around 1902.

Chill a martini glass with ice and water
2 oz white rum
1 oz fresh lime juice
½ oz simple syrup

Shake vigorously over ice, empty the glass, strain and garnish with a lime slice.

Hemingway Daiquiri or Papa Doble

"I drink to make other people more interesting."
—Ernest Hemingway

Yes, this drink comes from Florida, invented by Papa himself, but the new wave of interest in rum has brought it back to the Crescent City. The servers called it Double Papa because of course the writer liked them tall.

2 oz white rum
¾ oz fresh grapefruit juice
½ oz fresh lime juice
¼ oz Luxardo Maraschino Liqueur
¼ oz simple syrup

Shake vigorously over ice, empty the glass, strain and garnish with a lime slice.

Sportsman's Paradise

Galatoire's 33

2 oz Pilar Dark Rum
2 oz dark creme de cacao
1 oz pineapple juice
1 oz orange juice

Shake with ice and serve with orange garnish.

Hurricane

The name for this iconic New Orleans cocktail actually comes from the glass it is served in at Pat O'Briens—a riff on a hurricane lamp. Did you know that exactly ten dollars in pennies can fit in a Hurricane glass? (That really has nothing to do with anything, it is just a fun fact.) Anyway, before embarking on this classic, you have to ask yourself, "Do I really want to do this?" With two rums and fruit juice, especially on a hot day, it is easy to get blown away by the Hurricane.

2 oz light rum
2 oz dark rum
1 oz passion fruit juice
1 oz orange juice
½ oz fresh lime juice
½ oz simple syrup
½ oz grenadine

Garnish with an orange slice and cherry.

Coke and a Smile

By Dré Glass at Pearl Wine Company
Another cocktail shout-out to the "Real Thing," think of this as an elegant cherry Coke. This has a satisfying chocolate-covered cherry finish. A coupe glass is that wide glass Americans used to serve bubbly in before we figured out champagne flutes.

1 ½ oz Black Magic Rum
½ oz Luxardo Maraschino Liqueur
½ oz fresh squeezed lime juice
½ oz cola syrup
1 bar spoon Luxardo cherry syrup

Combine all ingredients into a shaker. Shake and strain into a coupe glass and garnish with two Luxardo cherries and a lime twist.

Hurricane drink. *By Shubert Ciencia (Flickr: Hurricane (New Orleans, Louisiana)) [CC BY 2.0 (http://creativecommons.org/licenses/by/2.0)], via Wikimedia Commons.*

Brunswick Sour

By James Rall at Tujague's
Mixmaster James Rall reaches back to 1935 at the Old Hotel Brunswick in New York to re-create a version of this odd but refreshing drink.

2 oz white rum
1 oz triple sec
1 oz lime juice
1 oz cabernet sauvignon

Shake the first three ingredients over ice, pour into rocks glass, then float the red wine on top. Garnish with lime slice.

Shady Lady

SoBou Restaurant

1 part Bayou Satsuma Rum
1 part fresh-squeezed grapefruit juice
1 part cava or prosecco
Grapefruit peel and thyme for garnish

Combine the liquid ingredients over ice in a rocks glass and garnish. Grapefruit lovers may want to add an extra splash of juice, and do not forget the thyme. It gives this drink the earthy aroma of Thanksgiving.

Honey Buzz Milk Punch

By Laura Bellucci at SoBou
Cheerios is not just for breakfast anymore, but then, was it ever? This is an excellent variation on the classic milk punch.

1 ½ oz Honey Nut Cheerios–infused rum
½ oz honey syrup
Splash Holiday Pie Bitters
4 oz milk

Infusing the rum is easy: Dump the Cheerios in the bottle for a week or so, then strain.

Honey syrup is simple syrup made with honey instead of sugar. Mix equal parts honey into warm water and heat on stove until they are totally mixed. Refrigerate.

Holiday Pie Bitters is an invention of New Orleans's own Scot Maddox, whose company, El Guapo Bitters, offers this allspice, nutmeg effect.

Shake over ice, serve in a rocks glass.

Garnish with a poof of nutmeg and some dry Honey Nut Cheerios on a drink skewer.

Sandy Bottoms

By Denzel Brown at Atchafalaya
Sandy Bottoms, as in what happens when folks sit on a beach. This masterpiece comes from "born 'n' raised in New Orleans" Denzel Brown. The cocktail uses a version of rum that they probably drank 200 years ago in the Crescent City: Rhum Vieux Agricole. It is a meticulously distilled rum with added volcanic spring water from Martinique. More impressive, however, are the homemade ingredients all from the

hand of Brown himself. Allspice dram is a brown sugar syrup infused with crushed allspice berries. His mixed berry syrup is a reduction of all the major berries—blueberry, blackberry, raspberry and strawberry—and sugar. And it is served in a really cool brass pineapple tumbler.

2 oz Rhum JM Blanc
½ oz Allspice dram
¾ oz mixed berry syrup
½ oz lime juice

Shake with ice, serve over ice in a golden pineapple with slice of lime and an umbrella.

Guinea Pirate

By Cameron Martinsen at Tujague's
A drink with a name like this cannot be left out of a book about New Orleans drinking. Of course, he makes his own syrups. Pisco is a Peruvian brandy. Full of surprising flavors, it is not only exotic but looks exactly like what a hot subtropical drink should look like.

2 oz rum
2 oz pisco
½ oz ginger liqueur
1 oz passion fruit juice
Splash cinnamon syrup
Splash grapefruit bitters
Splash angostura bitters

Combine and shake with crushed ice, serve tall.

French 1718

By Your (Not-so) Humble Author

1 ½ oz 1718 Tricentennial Old New Orleans Rum
Dash of simple syrup
Splash of Grand Marnier or orange bitters
4 oz champagne

This twist on the classic French 75 replaces gin with the tricentennial tribute rum from New Orleans's own distillery, and an orange note plays better with the rum than lemon. Garnish with orange peel.

Bananas Foster

In 1951, New Orleans was home to United Brands; we know them today as Chiquita Banana. Tons and tons of bananas were coming into New Orleans. Over at our treasured Brennan's Restaurant, owner Owen Brennan challenged his chef, Paul Blange, to make a good dessert out of bananas. He created this iconic dessert. It is named for a friend of Brennan's, Richard Foster. Not a drink, but this flaming joy combines New Orleans and rum. It has got to be included! This recipe comes directly from Brennan's Restaurant.

1 Ounce Butter
½ Cup Light Brown Sugar
¼ Tsp Cinnamon
1 ½ Ounces Banana Liqueur
½ Banana Per Person
1 ½ Ounces Aged Rum

Combine butter, sugar and cinnamon in a flambé pan.
As the butter melts under medium heat, add the banana liqueur and stir to combine.
As the sauce starts to cook, peel and add the bananas to the pan.

Cook the bananas until they begin to soften (about one to two minutes).

Tilt back the pan to slightly heat the far edge. Once hot, carefully add the rum and tilt the pan toward the flame to ignite it.

Stir the sauce to ensure that all of the alcohol cooks out.

Serve cooked bananas over ice cream and top with the sauce in the pan.

Drunken Apples

(Drunkenly created by the author one rum-filled Thanksgiving)

Apples
Spiced rum
Butter
Vanilla
Brown sugar
Cinnamon stick

Core the apples (before you get drunk). Don't peel. Place them in their own aluminum foil cradle. Fill the center with all the other stuff. Wrap up the foil. Put in an oven at 350 degrees for fifteen minutes, or until the apples are mushy. Serve hot. If you open your foil and the sugar/butter has made an edge coating, you did good.

CONTACT INFORMATION FOR PLACES MENTIONED IN THE BOOK

DISTILLERIES

Old New Orleans Rum
2815 Frenchmen Street
New Orleans
504-945-9400

Bayou Rum Distillery
20909 Frontage Road
Lacassine
337-588-5800

Donner Peltier Distillers,
 Rougaroux Rum
1635 St. Patrick Street
Thibodaux
985-446-0002

Lula Restaurant Distillery
1532 St. Charles Avenue
New Orleans
504-267-7624

Seven Three
301 North Claiborne Avenue
New Orleans
504-265-8545

Roulaison Distilling
2727 South Broad Avenue,
 Suite #103
New Orleans
504-517-4786

VOODOO SUPPLIES AND INFORMATION

Not a complete list but these are convenient for guests to visit from downtown.

F and F Botanica
801 North Broad Street
504-482-5400

Island of Salvation in the Healing
2372 St. Claude Avenue
504-948-9961

The Voodoo Museum
724 Dumaine Street
504-680-0128

Voodoo Authentica
612 Dumaine Street
504-522-2111

Bars and Restaurants

Atchafalaya Restaurant
901 Louisiana Avenue
New Orleans
504-891-9626

Napoleon House
500 Chartres Street
New Orleans
504-524-9752

Bourbon House
144 Bourbon Street
New Orleans
504-522-0111

Pat O'Brien's
718 St. Peter Street
New Orleans
504-525-4823

Brennan's
417 Royal Street
New Orleans
504-525-9711

Pearl Wine Company
3700 Orleans Avenue, #1C
New Orleans
504-483-6314

Felipes on Carrollton
411-1 North Carrollton Avenue
New Orleans
504-288-TACO (8226)

Pirates Alley Café
622 Pirates Alley
New Orleans
504-524-9332

Galatoires
209 Bourbon Street
New Orleans
504-525-2021

SoBou
310 Chartres Street
New Orleans
504-552-4095

Lafitte's Blacksmith Shoppe
941 Bourbon Street
New Orleans
504-593-9761

Tujagues
823 Decatur Street
New Orleans
504-525-8676

BARREL MAKERS

A PARTIAL BIBLIOGRAPHY

Books

Andrist, Ralph. *Steamboats on the Mississippi*. Mahwah, NJ: Troll Communications, 1988.

Asher, Sally. *Hope & New Orleans: A History of Crescent City Street Names*. Charleston, SC: The History Press, 2014.

Chase, John Churchill. *Frenchmen, Desire, Good Children…And Other Streets of New Orleans!* Avon, MA: Simon and Schuster, 1997.

Conrad, Glenn R., ed. *A Dictionary of Louisiana Biography*. Lafayette: Louisiana Historical Association, 1988.

Devol, George. *Forty Years a Gambler on the Mississippi*. New York: George H. Devol, 1892.

Funderburg, J. Anne. *Bootleggers and Beer Barons of the Prohibition Era*. Jefferson, NC: McFarland & Company, 2014.

Gayarré, Charles. *History of Louisiana, Volume 3*. New Orleans: James Gresham, 1879.

Greaves Cowan, Walter. *Louisiana Governors: Rulers, Rascals, and Reformers*. Jackson: University Press of Mississippi, 2009.

Hough, Emerson. *Ultimate Collection—19 Western Classics* etc. Online collection of short stories from 1903 to 1925.

Jackson, Andrew. *The Papers of Andrew Jackson: 1770–1803*. Knoxville: University of Tennessee Press, 1980.

Laborde, Errol. *Mardi Gras: Chronicles*. New Orleans: Pelican Publishing, 2013.

Lythgoe, Gertrude. *The Bahama Queen: The Autobiography of Gertrude "Cleo" Lythgoe*. New York: Exposition Press, 1964.

Montero de Pedro, Jose. *The Spanish in New Orleans and Louisiana*. New Orleans: Pelican Publishing, 2000.

Powell, Lawrence N. *Accidental City*. Cambridge, MA: Harvard University Press, 2012.

Rodriguez, Jaime O. *"We Are Now the True Spaniards": Sovereignty, Revolution, Independence*. Palo Alto, CA: Stanford University Press, 2012.

Rourke, Constance. *American Humor: The Study of the National Character*. San Diego, CA: Harcourt, 1931.

Schafer, Judith. *Brothels, Depravity, and Abandoned Women, Illegal Sex in Antebellum New Orleans*. Baton Rouge: Louisiana State University Press, 2009.

Starr, Blaze, and Huey Perry. *Blaze Starr: My Life As Told by Huey Perry*. Westport, CT: Praeger Publishers, 1974.

Taussig, Charles William. *Rum Romance & Rebellion*. New York: Minton, Balch and Company, 1928.

Twain, Mark. *Life on the Mississippi*. Boston: James R. Osgood & Company, 1883.

Walker, Alexander. *Jackson and New Orleans*. New York: J.C. Derby, 1856.

Websites

https://daily.jstor.org/a-brief-history-of-drinking-alcohol/.

http://discoverhistoricamericatours.com/rums-history-new-orleans.

https://gonola.com/things-to-do-in-new-orleans/mardi-gras-early-years-nolahistory.

https://gonola.com/things-to-do-in-new-orleans/arts-culture/nola-history-jean-lafitte-the-pirate.

http://knowledgenuts.com/2013/07/27/gertrude-lythgoe-female-rum-runner/.

http://medianola.org/discover/place/1284/Regulation-of-Gambling-in-Colonial-and-Antebellum-New-Orleans.

https://medium.com/@tonykail/invoking-spirits-hoodoo-voodoo-african-religions-in-the-alcohol-industry-389e3b6dfd2d.

https://muse.jhu.edu/article/556884/summary.

http://president.loyno.edu/pioneer-jesuits-south.

https://sallyjling.org/2011/06/28/gertrude-lythgoe-fascinating-women-of-prohibition/.

http://www.fox8live.com/story/17222135/heart-of-louisiana-descendants-of-jean-lafitte.

https://www.jstor.org/stable/44195643.

http://www.kislakfoundation.org/prize/200102.html.

http://www.mardigrasneworleans.com/history.html.

http://www.nationalcrimesyndicate.com/silver-dollar-sam-creation-new-orleans-crime-family.

http://www.neworleans.me/journal/detail/1359/A-City-of-Bad-Temperance.

https://www.thrillist.com/drink/new-orleans/new-orleans-distillery-boom.

https://www.washingtonpost.com/news/retropolis/wp/2017/05/19/new-orleans-seethed-under-union-occupation-then-rude-women-were-warned-theyd-be-treated-as-whores/?noredirect=on.

http://xroads.virginia.edu/~hyper/rourke/ch02.html.

http://xroads.virginia.edu/~hyper/rourke/cover.html.

Newspaper, Magazines, Internet and Scholastic Articles

Herskovits, Melville. Recordings of tribal chants in Africa. Collected papers. Schomburg Center for Research in Black Culture, Manuscripts, Archives and Rare Books Division, The New York Public Library, 1966.

Langue, Frédérique. *Francisco Rendón, intendente americano: La experiencia zacatecana:* https://www.colmich.edu.mx/relaciones25/files/revistas/053 FrederiqueLangue.pdf.

Lemmon, Alfred. *New Orleans and the Spanish World.* Concert program. The Historic New Orleans Collection and Louisiana Philharmonic Orchestra, 2015.

Milwaukee Journal

Mizell-Nelson, Catherine. "Alejandro O'Reilly" knowlouisiana.org Encyclopedia of Louisiana.

New Orleans Advocate

New Orleans Bee

New Orleans Times-Picayune States Item and all the earlier incarnations of that paper

New York Times

Pasquier, Michael. *The Invisibility of Voodoo, or, the End of Catholic Archives in America.* https://www.jstor.org/stable/44195643. American Catholic Historical Society, 2014.

Register of Debates in Congress, Volume 11; Volume 62

Richard, Dr. Charley. *200 Years Of Progress In The Louisiana Sugar Industry:* http://www.assct.org/louisiana/progress.pdf.

Scribner's magazine, Volume 28, Edward Livermore Burlingame, Robert Bridges, Alfred Dashiell, Harlan Logan

ABOUT THE AUTHOR

Mikko Macchione has been writing and talking about New Orleans for over thirty years. He has collaborated with renowned photographer Kerri McCaffety on more than a dozen books and articles. He has received two Independent Publishers Awards (IPPY) for his work on *Majesty of the French Quarter* and *Napoleon House*.